START TAKING GREAT
LANDSCAPE
Photographs

Chris Weston

photographers'
pip
institute press

First published 2005 by

**Photographers'
Institute Press / PIP**

an imprint of
The Guild of Master
Craftsman Publications Ltd,
166 High Street, Lewes,
East Sussex BN7 1XU

ISBN 1 86108 304 1

Production Manager: Hilary MacCallum
Managing Editor: Gerrie Purcell
Photography Books Editor: James Beattie
Art Editor: Gilda Pacitti

Typeface: Delta
Colour reproduction by Masterpiece, London
Printed by Hing Yip Printing Co. Ltd.

START TAKING GREAT
LANDSCAPE
Photographs

Chris Weston

Contents

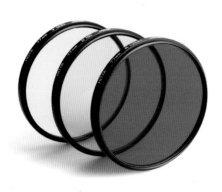

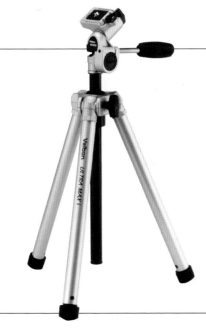

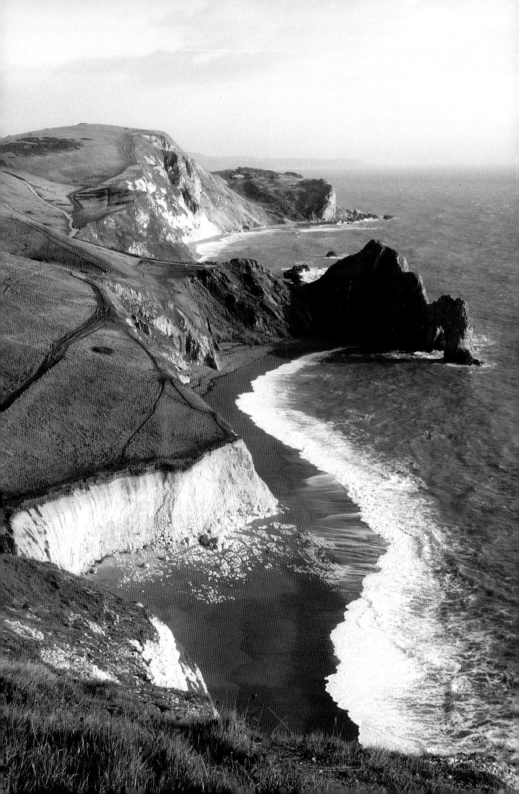

Introduction

◄ *Photographing beautiful landscapes is a question of learning how to see as a camera sees and then using the tools at your disposal to interpret personal emotion into visual art.*

How often do you take a photograph of a fantastic scene, only to find that the results are disappointing? Don't worry, you're not alone. Every photographer goes through this, and the reason is that what we see with our eyes and what the camera records are always two different things.

The key to landscape photography is learning to see like a camera sees and being able to use the tools at your disposal, such as lenses and filters, to overcome the limitations of the technology. This book will help you get to grips with some essential photographic techniques and help you to visualise the landscape in photographic terms. From the basics of choosing the right equipment, and getting the most from it, to recognising and incorporating the patterns of nature, the ideas and skills covered in the following chapters will soon have you shooting like a pro. For the occasions when experience is the best guide, there are some simple solutions to those difficult photographic problems that always occur when you have to deal with the unpredictability of Mother Nature.

There are also a number of simple exercises to help you along the way. Each is designed to get you thinking about your photography in a more artistic and practical way. As you progress through the book and complete each one, you will begin to find that your appreciation of the art of landscape photography grows, as does your ability to use the tools at your disposal. To get the most out of this book, you need to put something into it. The more effort you put into carrying out the hints and tips contained here the more your photography will improve, and soon you'll find that you have started taking great landscape photographs.

1

WHAT MAKES A BAD LANDSCAPE PHOTOGRAPH?

•

Common Mistakes

•

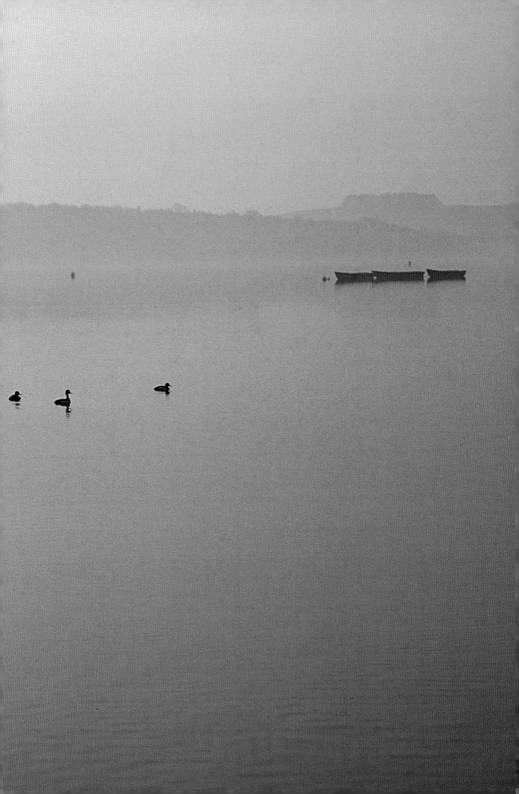

ONE **COMMON MISTAKES**

In order to learn how to make great images it's important that you first understand what makes a poor one. So here are some of the many mistakes that often spoil what could otherwise have been a great shot.

A great picture is often hard to define. Every time you ask a different photographer what he or she likes about an image you will get a different answer. One way of looking at it is to turn the question on its head and ask 'what makes a bad picture?' This allows us to examine some of the problems that commonly spoil images.

POOR COMPOSITION

The lack of thought given to composition is, perhaps, the main problem with most poor landscape photographs. Not considering how all the individual components within the image work together and how they are positioned within the frame leads to weak photographs and lots of wasted photographic opportunities.

>> **SEE** pages 13–18 for some examples of how the 'point-and-click' approach can let you down.

POOR CAMERA TECHNIQUE

Alongside poor composition, photographs that have great potential are often ruined by poor camera technique. Modern cameras are highly sophisticated and boast many fully automated modes – often including a specific 'Landscape' mode. While these are a great way of starting out in photography, knowing how to use your camera to its full potential is as important today as it has ever been.

>> **SEE** pages 19–27 for some examples of how poor camera technique can ruin a photo.

ⓧ Bad Cropping

Chopping off important elements within the picture space or parts of your main subject by positioning the camera poorly or selecting the wrong focal length will completely ruin what may be an otherwise excellent picture.

>> **GETTING IT RIGHT** pages 42–6

▼ ▼ *In the first image below, poor framing has cut off the tops of the trees along the hillside. In the bottom image, a reworked composition gives the same trees room to grow within the picture space.*

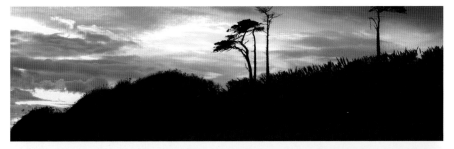

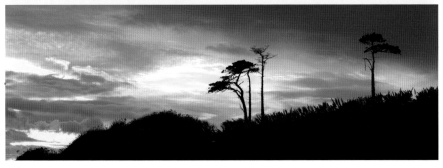

⊗ Clutter

Badly placed picture elements can distract you from the key subject in a photograph and take your eye away from the main area of the image. This visual clutter can be either natural – where too many objects are competing for your attention – or man-made – such as litter or unsightly electrical pylons. Whatever the cause, by failing to scrutinise the viewfinder for these unwanted picture elements you run the risk spoiling what may have been a super shot.

>> **GETTING IT RIGHT** pages 108–13

◄▼ *The bare tree branch on the left in the top picture spoils this beautiful sunset scene. The tighter crop below tidies up the composition and removes the distracting clutter.*

⊗ Subject Position

Why do some photographs just seem to 'work', while others don't? Often it has a lot to do with the main subject's position, and this is particularly true in landscape photography. There are some rules that can help you, for example, the rule of thirds. While, not every rule applies in every situation they can often be employed to make your pictures more aesthetically pleasing.

Placing the main subject too close to the edge of the picture space is a related problem that will make your images seem constricted. On the other hand placing it in the centre can isolate it from the surrounding elements, which become insignificant – an effect that can be useful in some fields of photography but rarely works for landscapes.

>> **GETTING IT RIGHT** page 116–7

▼▼ *Where you position the main subject determines how it relates to the rest of the scene. Compare the two images, below. In the top image, the central positioning has isolated the chapel from its surroundings.*

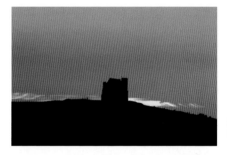

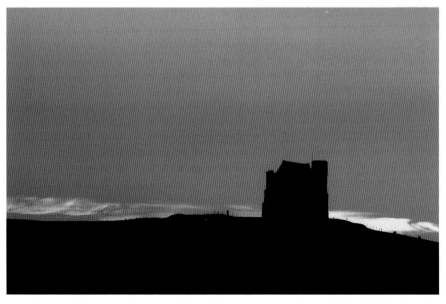

ONE

15

COMMON MISTAKES

Messages

Pictures that lack any real purpose will fail to hold the viewer's attention because they having nothing to communicate. It's important that every time you compose an image you give some thought to what it is you want your photograph to 'say' to the viewer.

>> **GETTING IT RIGHT** pages 118–9

▲▼ *What message are your images communicating to the viewer? The image above lacks any message of interest. A little thought and a discerning eye have greatly improved the composition, below.*

16

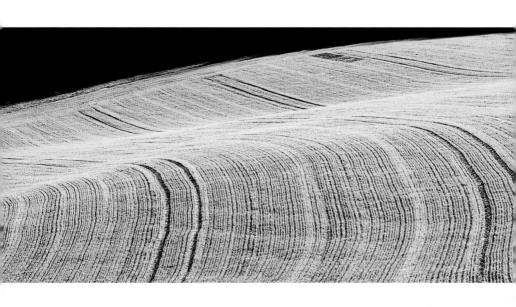

⊗ Static Images

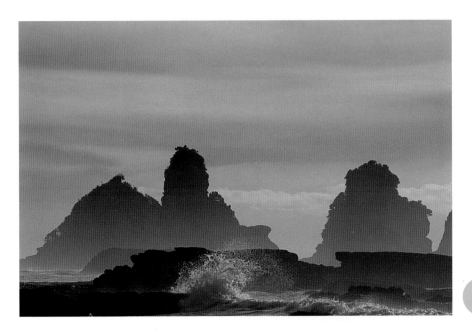

You may well be thinking, 'aren't all images static?' Practically, yes they are. But visually you can create energy within the frame that helps to engage the viewer and compel them to explore the whole picture space. Being able to draw the viewer into the image like this can really help your images to stand out from the crowd.

>> **GETTING IT RIGHT** pages 100–1

▲ ▲ *Static images such as the one immediately above aren't always a bad thing. However, a landscape that lends itself to a dynamic composition, such as this seascape, benefits from a picture design that captures visual energy, such as in the top image.*

⊗ Too Much Space

The field of view is determined by where you stand and your choice of lens. Ideally, you should only include as much of the scene as is relevant. If you stand too far back from the subject and/or choose a lens with too wide an angle of view you can end up with pictures that include too much irrelevant information.

>> **GETTING IT RIGHT** pages 42–6

▼ ▼ *Some landscape photographs suffer greatly from the temptation to try and fit too much into the frame, like the photograph on the left. Selective cropping, as shown in the image on the right, can greatly improve images by giving them more impact.*

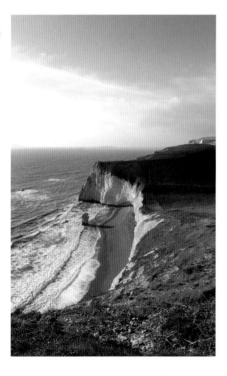

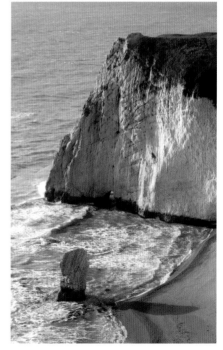

✗ Camera Shake

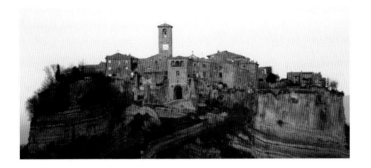

Everybody thinks that they can hand-hold a camera at slower shutter speeds than everyone else. I know this because I hear it so often from people who attend my workshops. Unfortunately it is normally a case of people not scrutinizing their own images, and even if the effect of camera shake is only slight it can ruin a good landscape photograph, especially if you want to enlarge it for display.

>> **GETTING IT RIGHT** pages 48–51

▲▼ *There really is no excuse for camera shake, as shown above, in landscape photography. Always use a tripod or some other form of solid support to make sure you achieve blur-free images, like the one below.*

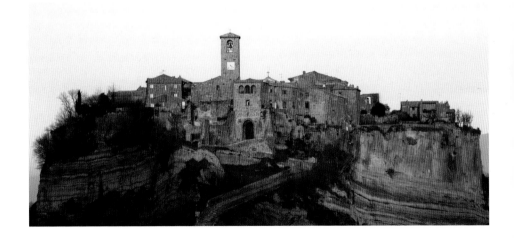

ⓧ Vignetting

Vignetting usually occurs when the angle of view of your lens is so wide that anything attached to the front of your lens, such as a lens hood or filter is caught in the picture around the corner edges. In some instances, particularly with digital capture – in which case it is often known as shading – and panoramic format photography, vignetting can be caused by light fall-off. It's important that you be aware of these limitations and compensate for them accordingly.

>> **GETTING IT RIGHT** page 52–3

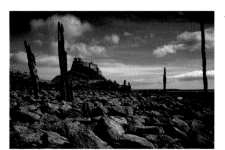

◀▼ *Always check the corners of the viewfinder for vignetting, or shading, left. Also remember that few cameras have 100% viewfinder coverage and vignetting may occur even though it is not immediately visible. If in doubt, tighten up the composition by moving closer to the subject or using a longer focal length, below.*

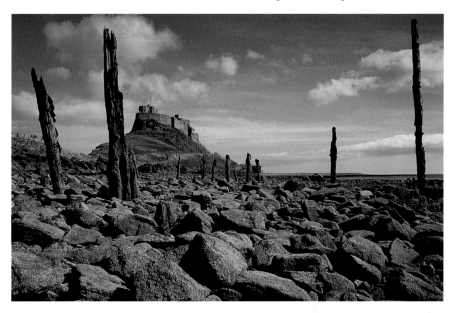

✕ Lens Flare

When shooting into the sun, failure to use a lens hood or some other form of lens shade may cause unsightly lens flare to appear on your images. This doesn't just cause the characteristic blobs of bright colour but also the loss of definition throughout the rest of the image.

>> **GETTING IT RIGHT** page 79

▲▼ *Lens flare, above, caused by stray light reflecting off the glass in the lens barrel, will ruin an otherwise good image, below.*

⊗ Selecting the Wrong Lens

▲▼ *These two images were taken with the same focal length lens. By changing the camera position, however, I have turned a poorly composed photograph, below, into a commercially succesful one, above.*

Many photographers select the lens they're going to use based on where they're standing in relation to the subject. This is the wrong approach. You should position the camera based on the lens you need to use to create the effect you want. It's a question of who or what is in control of the picture making process – you or the equipment? You should be prepared to move around, even if that means hiking some distance, in order to get the perfect composition.

>> **GETTING IT RIGHT** pages 42–6

✖ Bad Lighting

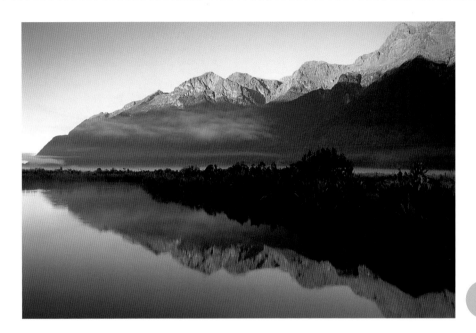

Nothing does more to ruin a beautiful scene than photographing it under bad lighting conditions. The typical error is letting flat lighting – the type you generally find around the middle of the day – dull the picture. This produces an image that lacks a broad range of tones between highlight and shadow – contrast – which is what creates the form in an image. To capture great landscape images it is often best to wait until the lighting is at an acute angle to your subject and has a rich golden glow about it – usually in the early morning and late afternoon. This is why those times of the day are referred to as the 'golden hours'.

>> **GETTING IT RIGHT** pages 74–81

▲▼ *Flat lighting, as seen in the picture below, results in an aesthetically poor photograph. Waiting for the right light, often found early in the morning, above, or late in the afternoon, will give your images more impact.*

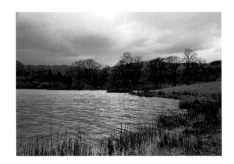

⊗ Poor Exposure

Have you ever had pictures back from the processing lab that look dark and dull, or where the bright areas are so 'washed out' that they lack any detail? The problem here is poor exposure – either underexposure (too dark) or overexposure (too bright). Getting the exposure right is one of the more complicated techniques and can be difficult to master. Unfortunately switching the camera to full auto mode and letting it do all the work won't solve the problem.

>> **GETTING IT RIGHT** pages 90–105

◀▲ *A well-exposed image, top, is essential to great landscape image: try to avoid underexposure, middle, and overexposure, bottom.*

ⓧ Poor Focus

Focus is another area that can badly let down your pictures. One of the main problems is focusing on the wrong subject, which is often caused by the autofocus mechanism in your camera. Autofocus was a great invention that has helped many photographers to get pictures that would otherwise have been impossible to take. However, relying on autofocus without understanding what your camera is doing is a sure way of coming unstuck.

The other main problem you'll come across when focusing is getting enough of the image sharp from foreground to background. This is because lenses can only focus on a single point and everything in front of or behind that point will be technically out of focus. Whether it appears sharp to the human eye, however, will depend on how much depth of field there is. Not enough and areas of your landscapes will appear to be blurred.

>> **GETTING IT RIGHT** pages 82–9

▼► *Getting your focus in the right place is critical as it ensures that the important parts of the image are rendered sharp, below, instead of being indistinct, right.*

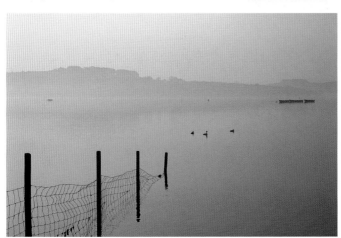

ⓧ Boring Subjects

The final thing that can cause your images to lack sparkle and that compelling punch is the choice of uninteresting or uncoordinated subjects. For photographs to be appealing they have to evoke an emotional response from the viewer. Choosing a subject that you wouldn't look twice at in real life and photographing it in an uninteresting way will not make your pictures stand out. Similarly, taking a picture with more than one subject and nothing to link them, either visually or emotionally, will simply confuse the issue and the viewer will quickly move on.

>> **GETTING IT RIGHT** pages 110–113

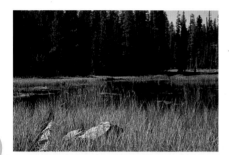

◀▼ *Photographing a common scene from an unusual perspective, below, will grab the viewer's interest and hold their gaze. Conversely, a bland scene photographed without imagination will simply result in a boring picture, left.*

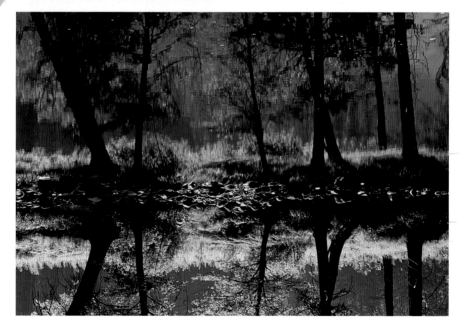

26

Try it out **APPRAISING YOUR OWN WORK**

Here's an exercise to help you identify where your pictures are going wrong and get you thinking about the essential techniques for taking great landscapes.

1 Select around a dozen of your pictures and then ask the following questions, using the table provided.

2 Now take a closer look at your pictures using Part II: How to take great landscape photographs, and consider how you would take the picture again, what you would do differently?

3 If it's possible to go back and photograph the same location, do so following the thoughts you've identified.

Y	N	
❏	❏	Do the individual components within the frame relate to each other? If no see page 113.
❏	❏	Have you missed out important parts of the picture? If yes see pages 42–6.
❏	❏	Are there too many elements within the picture? If yes see page 111.
❏	❏	Is the subject positioned effectively within the frame? If no see page 113.
❏	❏	Does your picture convey a message? If no see pages 118–9.
❏	❏	Could you crop in tighter on the image without losing any important elements? If yes see pages 42–6.
❏	❏	Did you hand-hold the camera and are details in your photograph at all blurred? If yes see pages 48–51.
❏	❏	Are the corners of the image significantly darker than the middle? If yes see page 52–3.
❏	❏	Are there any blotches of lens flare? If yes see page 80.
❏	❏	Could you have used a different lens to take a similar photograph? Would it help improve the composition, and sense of perspective if you used a longer or shorter focal length? If yes see pages 42–6.
❏	❏	Is the lighting as good as it could be? Would the image be improved if you photographed it under different conditions? If yes see pages 74–81.
❏	❏	Do any areas of highlight or shadow completely lack detail? If yes see pages 90–105.
❏	❏	Is the focus in the right place, and are important foreground and background elements in focus? If no see pages 82–89.
❏	❏	Is the subject itself interesting? Were there other similar subjects that would work better with the image you are creating? If yes see pages 110–113.

2

HOW TO TAKE GREAT LANDSCAPE PHOTOGRAPHS

•

Equipment

•

Location

•

Light

•

Focusing

•

Exposure

•

Design

•

TWO **EQUIPMENT**

Part of any artform is using the right tools for the job. It's important to learn not just what equipment is best for taking landscape photographs, but what equipment is best for you.

Cameras and Formats

Buying a Camera

A camera should be able to withstand the odd rain shower and a bump or two without falling apart or malfunctioning. Search the Internet for reports as people often post messages on forums about problems with specific camera models.

Although many people will try to convince you otherwise, there is no such thing as the perfect camera. You will always have to compromise in one area or another: whether it is on price, quality or convenience. All cameras have many good and bad points. Choosing the right camera is a matter of knowing what demands you will make and choosing a model that will fulfil them. For landscape photography, many of the functions you would associate with modern camera design are little used and so your choice is widened.

TIPS FOR CHOOSING A CAMERA SYSTEM

✔ Make sure you feel comfortable holding the camera. Try it out in the store and check to see that the controls are accessible and how heavy the camera is – remember, you may have to carry it some distance.

✔ Most viewfinders do not display the whole scene so make sure that the model you choose has a viewfinder coverage of at least 95%. This is important for good composition.

✔ Rapid subject movement is not an issue in most landscape photographs so autofocus is not important. It is useful to buy a camera that allows you to switch to manual focus should you need to, or alternatively you could invest in an older camera that only offers manual focus.

✔ As well as autofocus most modern cameras also feature autoexposure (AE) systems. These often provide a number of preset modes that include a landscape setting, but more importantly should offer aperture-priority, shutter-priority and manual modes.

✔ The camera should have a standard tripod-mount socket on the base.

✔ The camera should accept either a mechanical shutter-release cable or an electronic shutter release. Electronic shutter releases are often dedicated to one particular camera model so check the price of the release before you buy your camera; they can be surprisingly expensive.

✔ For long-time exposures a camera should have pre-defined settings up to 15 or even 30 seconds. Additionally, make sure it has a B(ulb) or T(ime) setting to allow you to open the shutter for even longer periods.

✔ A mirror lock-up facility is very useful on SLR cameras, for minimizing vibrations. In digital cameras the mirror lock-up may be referred to as the 'anti-shock' mode.

✔ When considering digital cameras, check that the camera's sensor has a resolution of at least six effective megapixels, and a noise-reduction function for long-time exposures.

NON-INTERCHANGEABLE LENS COMPACT CAMERAS

There is a huge variety of film and digital compact cameras on the market; ranging from the most basic pocket-sized model to complex and expensive cameras that rival the functions of SLRs.

 ADVANTAGES

Small – sometimes pocket-sized – and lightweight.

Often relatively cheap compared to the equivalent SLR cameras, especially in the case of digital cameras.

Point-and-shoot technology can take some of the guesswork out of the technical side of photography as you learn the ropes.

Better specified models can offer similarly advanced options to SLRs.

A large range of models at various prices are available.

 DISADVANTAGES

Very limited scope for accessories, especially compared to SLR cameras.

No facility to change lenses.

The compact style limits the size of the lens and often its quality.

Users may not be able to override some of the automated features on basic models.

The placement of the viewfinder may cause the problem of parallax, where what can be seen through the viewfinder is not quite the same as what will appear in the final frame.

35mm FILM SINGLE LENS REFLEX (SLR) CAMERAS

At the time of writing the 35mm film camera is the most commonly used camera in non-professional landscape photography. There is a large range of 35mm SLRs available from a number of manufacturers as well as many accessories, lenses and flash units.

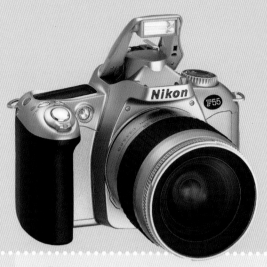

 ADVANTAGES

Small and relatively lightweight, 35mm SLRs are easy to carry in the field.

Good system back-up means that lenses and accessories are plentiful.

35mm film is easy to load and store safely, and frame for frame is cheaper to buy and process than larger formats.

The combination of fully automated features and user-defined functions makes the 35mm SLR a good camera for beginners and more experienced users alike.

Basic models are inexpensive.

Plenty of choice in models and levels of sophistication.

 DISADVANTAGES

The small format film limits the quality of significant enlargements (anything beyond 10x8in).

A large number of functions can make operation more complicated than is strictly necessary for landscape photography.

Many of the available functions that you will pay for are redundant for landscape work.

It can be very easy to become reliant on the camera's technology instead of developing your own photographic skills and understanding.

35mm FILM RANGEFINDER CAMERAS

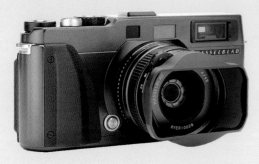

Although not ideal for landscape photography – because the off-lens viewfinder can make composition more difficult – the rangefinder camera does have some distinct advantages, if you can learn to manage its limitations.

 ## ADVANTAGES

Much lighter than even the 35mm SLR camera, and ideal for long haul travel and gruelling wilderness treks.

Rangefinder-coupled interchangeable lenses are much smaller than their SLR counterparts, reducing the size and weight of your backpack.

Because of the lack of need for a reflex mirror, the optical quality of the lenses made for rangefinder cameras is generally better than those made for SLR systems.

Retains the advantages of working with 35mm film.

Quiet operation means they can be used in restricted environments.

 ## DISADVANTAGES

You don't get a through-the-lens view of your subject making composition more challenging, although most modern rangefinder cameras adopt a system that provides a view very close to that 'seen' by the camera.

Because of the focusing systems used in rangefinder cameras, focusing can be more difficult, particularly if there are no distinctive contrasting objects within the scene.

The most comprehensive back-up systems are generally provided by the best manufacturers, which means that they can be expensive.

Some older 35mm rangefinder cameras that you will find second-hand don't provide the ability to interchange lenses.

DIGITAL SLR CAMERAS

Since becoming widely available and increasingly affordable 35mm-style digital SLRs have become popular with professional and amateur photographers alike. Now that many of the early technological problems have been ironed out, the image quality rivals that of film, and there are a host of other advantages to digital capture.

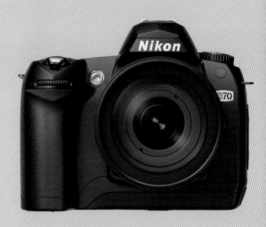

 ADVANTAGES

Cheap to run once you've covered the high initial expense as no film or chemical processing is required.

Immediate feedback of the captured image and image information via the LCD screen allows you to shoot, review and adjust for accurate results every time.

The digital sensor is far more flexible to work with than film.

For existing 35mm film SLR users, if you stay with the same manufacturer, you can normally use your existing lenses and equipment on a digital camera body.

Relatively small and lightweight, making for great portability.

 DISADVANTAGES

Expensive initial cost, particularly when compared to the equivalent film cameras. This includes buying some accessories such as memory cards that are often not included in the package.

Relies heavily on your having access to a computer and printer.

Requires a greater level of understanding of the complete photographic process if you are to get the most out of the digital image.

MEDIUM-FORMAT FILM CAMERAS

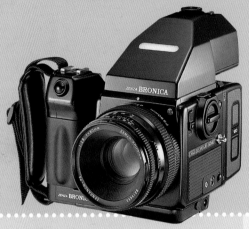

Medium-format film cameras use film that is larger than 35mm film, which is referred to as rollfilm. The most popular type – and the only widely available one – is 120 film, which can be used to give varying image sizes from 6cm x 6.45cm to 6cm x 17cm.

 ## ADVANTAGES

Often manually based, lacking autoexposure and autofocus functions, they are simple to use and are ideally suited to the slow pace of landscape photography.

The large image size produces a better quality negative or transparency than 35mm film, all other things being equal.

Can be cheap to purchase second-hand and a complete system in excellent condition can often be acquired for less than a 35mm-style digital SLR body.

Using a medium-format camera slows down the image taking process, which can help you to think more creatively.

Some models accept multiple film formats, allowing you to switch between image sizes for different scenes.

 ## DISADVANTAGES

Often much heavier than their 35mm film and digital counterparts, making them harder to travel with and heavier to carry.

You get far fewer shots on a roll of film, which means you'll be changing film more often – particularly when bracketing exposures.

Film loading is a more complicated process than for the 35mm canister system or inserting a memory card.

Can appear to be more complicated to operate than 35mm or digital SLRs although, in reality, once you've mastered the basics this often is not the case.

LARGE-FORMAT CAMERAS

Large-format photography is an almost unique discipline. Many of the most accomplished landscape photographers still use large-format cameras, as the image size allows some amazing results. Most people will never use a large-format camera, but as they are still popular amongst the elite of landscape photographers they are worth mentioning.

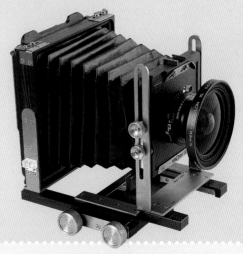

ADVANTAGES

The large format provides an impressive image quality, especially when viewing a transparency on a light box.

Movable front and rear 'standards' mean that you have almost complete control over the representation of perspective within the photograph.

Interchangeable backs allow you to use a variety of sheet film and rollfilm.

DISADVANTAGES

Large and unwieldy, need to be tripod mounted.

Large-format sheet film is very expensive, because of its size.

As the practice of large-format photography is very different from that of the smaller formats, it can take a lot of getting used to.

Although there are a few second-hand bargains to be had, most large-format cameras, lenses and backs are relatively expensive.

Large-format cameras are impractical for use in a wide range of other photographic subjects.

Film and Digital Formats

Aspect Ratio

Some people describe a format using its aspect ratio. This may sound complicated but it is simply the ratio of a frame's width to its height. For instance the size of a 35mm frame is about 36x24mm, so its aspect ratio is 3:2.

As you'll have seen from the last few pages on different types of camera; film formats and digital sensors come in different shapes and sizes. Part of the process of choosing a camera is deciding which format is best for you. Of course, some formats are better suited to landscape photography than others, and some cameras even allow you to switch between formats by selecting different backs or by inserting film masks.

Rectangular formats are the standard for most photography, and encompass a wide range of different film and sensor sizes. The resulting image is close to what we see with our own eyes, which perhaps partly explains its popularity. In landscape photography, the rectangular format works well because we generally perceive the landscape in linear terms, so this format can make composition easier. Square format cameras are also available, and at the other extreme there are panoramic cameras, which have an aspect ratio of 2:1 or greater. In other words the image that they produce is at least twice as wide as it is tall. Any format will take some getting used to, and you need to learn to 'see' like the camera.

35mm

35mm film is probably the most popular format around at the moment, and will be until it is replaced by digital photography. The small size of the film gives it both its strengths and weaknesses as it is cheap, easy to use and convenient to store and carry, although it is not as suitable for enlargement as other larger formats. Some – generally professional – digital cameras use a sensor that replicates the format of a 35mm frame.

Approximate image size (wxh): 36x24mm

6x17

SUB-35mm DIGITAL SENSORS

Most digital camera sensors, including APS-C sized sensors, replicate the 3:2 aspect ratio of a 35mm frame but are slightly smaller. Another popular aspect ratio is 4:3, which is used in the FourThirds industry standard.

Any lens used with a sub-35mm sensor will effectively have a narrower angle of view than when used with 35mm film. While the effect depends on the sensor size, it is often that of multiplying a lens's focal length by 1.5x, for instance a 50mm lens will give the effect of a 75mm lens. This causes landscape photographers problems, as wideangle lenses have a less pronounced effect.

Approximate image size: depends on camera

▼ *The diagram below shows the relative size of different film and digital formats. Typically, the larger the format size, the greater will be the reproduction quality of the finished image.*

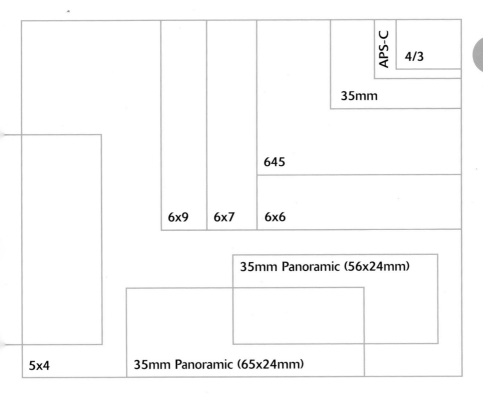

645

645 camera systems are often considered to be a halfway step between the larger medium format sizes and the smaller 35mm film systems. The cameras often have some of the features seen on smaller 35mm SLRs, such as autofocus, but they also offer the benefits of a larger original image size.

>> **SEE ALSO**
Frame Formats, pages 106–7

Approximate image size (wxh): 56x41.5mm

6x7

6x7 is sometimes referred to as the 'ideal format' as it is very close to the aspect ratio of some common US paper sizes, which means a 6x7 negative can be printed with very little cropping. These are popular medium format cameras with landscape photographers as they provide a large rectangular format transparency or negative without being as cumbersome as a large format camera.

Approximate image size (wxh): 69.5x56mm

6x9

There are very few 6x9 format cameras available; more common are 6x9 rollfilm backs that can be used in conjunction with large format cameras.

Approximate image size (wxh): 82x56mm

5x4

Unlike other formats, which are described in metric measurements 5x4in sheet film is described in inches. It is the most common size of film used in large format cameras. The large size of the original negative or transparency means that the images can be greatly enlarged, without losing quality. For many professional landscape photographers 5x4 is the format of choice. The advantages and disadvantages of large format photography are discussed on page 37.

Approximate image size (wxh): 120x95mm

6x6

The square format is particularly popular in commercial photography and has its own advantages. However, arguably, it is the least ideal for landscape work because we tend to think of the landscape in terms of space, which is better captured when using wider formats. Having said this, there are always exceptions, and it is possible to create some very striking compositions using this format.

Approximate image size (wxh): 56x56mm

35mm PANORAMIC

At the time of writing Hasselblad's Xpan and Xpan II cameras, are the only models that offer the ability to switch between a standard (36x24mm) frame and a panoramic (65x24mm) frame on the same roll of 35mm film. There are also interchangeable 35mm panoramic backs that can be used on medium format cameras, these normally measure 56x24mm.

Approximate image size (wxh): 65x24mm or 56x24mm

6x17

There are only a handful of very expensive 6x17 cameras on the market, but I've included the format here as an illustration of the extreme end of panoramic photography. More than any of the other formats, this takes a great deal of getting used to in order to make the most of, as it is so unusual.

Approximate image size (wxh): 168x56mm

Interchangeable Film Backs

The film backs on medium- and large-format cameras are often interchangeable enabling you to produce images with different dimensions.

Lenses

Lens Quality

Because the lens is one of the key determinants of image quality, especially clarity and contrast, it pays to buy the best lens that you can afford.

How the camera records the scene you're photographing is determined by your choice of lens. A mistake often made by photographers is to choose a lens that gives a frame-filling image depending on where they are standing at the time. While this makes for effortless photography it is a mistake. The key is to walk about and change your viewpoint to enable you to use the best lens for the job. But, what is the best lens? Well, here are some pointers.

ZOOM OR PRIME

All lenses can be split into one of two distinctions: zoom or prime. A prime lens has a fixed focal length, while a zoom offers a range of focal lengths that can be adjusted via a ring on the barrel. The optical quality of prime lenses used to be considered far superior to that of zoom lenses, however, the gap has closed and the more practical zoom lenses are now more popular. However, this is only true of 35mm and digital cameras as medium and large format systems rely almost entirely on prime lenses.

▼ Lenses can be either of a fixed focal length (prime) or variable focal length (zoom) type. Both have their advantages and disadvantages.

LENS TYPES AND ANGLE OF VIEW

Without getting too caught up in the science of optics, lenses come in three basic groups of focal length: wideangle, standard and telephoto. The standard lens is so-called because it gives a perspective that is close to that of the human eye. A wideangle lens has a wider angle of view than a standard lens, while a telephoto lens has a narrower angle of view. Zoom lenses are also often grouped using these terms, for example a lens with a large focal range might be referred to as a wideangle to telephoto zoom.

FORMAT	STANDARD LENS
4/3 Sensor	24mm
APS-C sensor	35mm
35mm	50mm
645	80mm
6x6	80mm
6x7	90mm
6x9	120mm
5x4	150mm

▲ *The focal length of a standard lens depends on the format of the film or sensor as shown in the table above.*

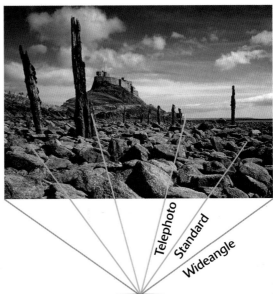

▶ *This diagram shows a simplified view of the effects of using lenses of different focal lengths. A standard lens gives an angle of view similar to that of human vision, while a telephoto lens shows a narrower angle of view and a wideangle lens a wider one.*

Field of View

A concept similar to magnification is field of view. Don't confuse this with the angle of view, it is related but different. The field of view denotes how wide and tall a subject can be fitted in the frame space at a given distance.

MAGNIFICATION AND PERSPECTIVE

Magnification and perspective are two distinct but easily confused subjects. Magnification refers to the size of the subject within the frame, relative to the size of the subject in real life. For example, a 0.01x magnification means that the subject image appears at one hundredth the size of the real subject. This might sound tiny but remember that you are trying to squeeze an image of a real-life subject onto a relatively small piece of film or a sensor. Take the example of a 33ft (10m) tall tree. To photograph the whole tree in portrait format with a 35mm camera means that the image will have to be 278x smaller than the real thing!

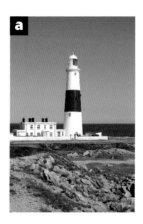
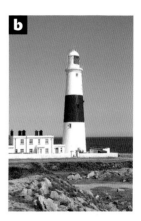
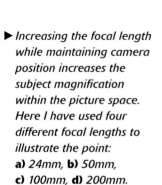

▶ Increasing the focal length while maintaining camera position increases the subject magnification within the picture space. Here I have used four different focal lengths to illustrate the point:
a) 24mm, **b)** 50mm,
c) 100mm, **d)** 200mm.

▶ *Altering the camera's position affects the image's perspective. Here the perspective is foreshortened when the camera is moved further away from the subject (**a** to **d**) even though the subject's size remains approximately the same because of the use of appropriate focal lengths.*

In practical terms the magnification of a subject is determined by the lens in use (in other words the angle of view) and the distance to the subject. If you stand in the same position then the higher the focal length the greater the magnification: the image magnification will double with every doubling of the lens's focal length. The same is true of subject distance: as a rule of thumb, if you halve the distance between you and the subject then the magnification will double. This effect is shown in the series of images opposite.

The photographic concept of perspective, on the other hand, is the size of the subject in relation to foreground and background elements within the frame. This is only affected by the distance to the subject. The further away that you are from the subject, the closer together these elements will appear to be. Conversely, the closer that you get to a subject the further apart the foreground and background elements will appear to be.

Telephoto lenses are often described as 'compressing perspective'; strictly speaking this is not true. It is simply that to represent the subject at a certain size within the frame you will need to be further away when using a telephoto lens than you would with a wideangle lens. This effect is shown to the right, where the subject distance has been altered but different lenses have been used to show the bale of hay the same size within the frame. Notice how the bale remains the same size but the varying distance has caused different amounts of the background to be included or excluded.

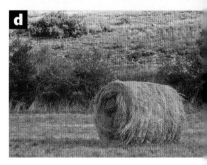

Lenses for Landscapes

Although landscape photography tends to be associated with wideangle lenses, I have often used as much as a 300mm telephoto lens for landscape work.

>> **SEE ALSO**

Too Much Space, page 18
Selecting the Wrong Lens, page 22

46

SPATIAL RELATIONSHIPS

Popular writing on basic photographic technique used to advise that to get a frame filling image of your subject you should use a telephoto lens, with its narrow angle of view, to cut out surrounding information and make the subject appear closer than it actually was. For sweeping vistas, the same texts advised using a wideangle lens that increased the angle of view and allowed you to cram more information into the picture space. Of course, there is nothing technically inaccurate about this advice but it does limit your creative licence. When you take a photograph you are making a statement to the viewer about that particular scene, and you should consider the effects of magnification and perspective when you choose your lens and the position you take your photograph from. You should evaluate the size of the subject within the frame and its relationship with other pictorial elements. Be aware of the effect of the various options, and how they can be used to affect the appearance of space within the image.

Here's an exercise to help you to get the most out of your lenses.

1 Take a day out with your camera and just one prime lens or restrict yourself to a single focal length on a zoom lens.

2 See how many pictures you can create with just that lens. Explore the area and be prepared to change your distance and viewpoint to each subject.

3 Review the images to assess how your position relative to the subject affects the composition of the picture.

4 When you've done this with one focal length lens, repeat the exercise with some others, choosing just a single prime lens or a single focal length on your zoom lens each time.

5 The purpose of this exercise is to get you thinking about how you can control composition by manipulating perspective, rather than relying on altering the focal length of the lens to suit your position.

47

TWO

EQUIPMENT

▶ *Never be afraid to experiment with your photography. Trying out new ideas and analysing the results is the best way to learn new techniques.*

Tripods

▼ A tripod is an essential accessory in landscape photography. There are many models available and you should take time to consider which is best for your needs. Acquiring a good tripod in the beginning, although often more expensive, is likely to save you money over time, and improve your photographs massively.

The first thing to consider when choosing a tripod is stability versus portability. Look out for the tripod's maximum load-bearing weight and ensure that your heaviest camera and lens combination doesn't exceed it. The general rule is; opt for the sturdiest model you are able to carry comfortably. Check for rigidity by opening the tripod to its maximum extension (minus the column, which I'll discuss shortly) and tap it gently with your hand. The more it moves, the less sturdy it is and the less capable it will be when working in high winds. One option to consider is buying a carbon fibre model, which although more expensive, usually weighs only two-thirds of the amount of traditional metal tripods. Some tripods also have sealed feet, which it is worth considering if you are going to be taking photographs near water or on boggy ground.

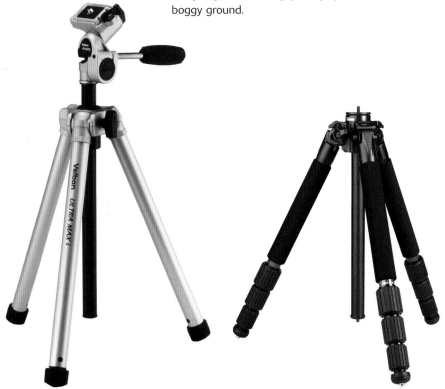

TRIPOD HEADS

There are two main types of tripod head: the 'ball and socket' and the 'pan and tilt'. Each has its virtues. A ball and socket head allows you to rotate the camera around a sphere and lock it in place where you choose. A pan and tilt head normally offers three axes of movement which can each be locked in place individually, this allows for a greater degree of accuracy when framing the subject. Remember to add the weight of the head to that of a tripod when considering buying a new tripod. Modern magnesium heads are strong and relatively lightweight and are worth considering if portability is a key factor in your decision-making.

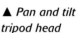

◀ *Ball and socket tripod head*

▲ *Pan and tilt tripod head*

QUICK-RELEASE TRIPOD HEADS

If you are likely to frequently change camera bodies when photographing a scene, maybe to change the type of film you are using or to switch formats, it is worth choosing a head with a quick-release mechanism. Quick-release heads not only save time when switching between cameras, but more importantly, they make the job far less fiddly and usually allow you to keep your gloves on in freezing conditions.

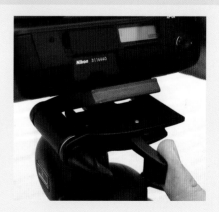

TIPS FOR USING A TRIPOD

Using a tripod might seem pretty obvious but, in reality, there's more to it than meets the eye. What's important to remember is that you're always trying to keep the camera as steady as possible and you should avoid doing anything that may compromise rigidity. Here are a few hints and tips:

✔ ▶ Always fire the shutter with a remote shutter release to avoid causing camera shake when pressing the shutter-release button. If you don't have a remote release with you, an alternative is to set the camera shutter on a short timer delay, press the shutter-release button and stand back.

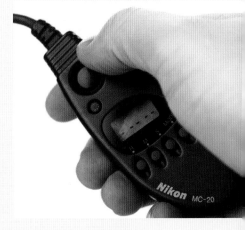

✔ ▼ Always place the legs at their maximum angle given the height you need whenever possible. The greater the area they cover the more sturdy the tripod will be.

✔ ▶ In windy conditions it helps to weight down the tripod with ballast, such as stones, rocks, or even your camera bag. Some tripods are equipped with a special hook and a ballast bag for just this purpose.

✔ Always make sure the camera is well balanced on the tripod head. If you are using a long lens then it may be better to attach the lens to the tripod via a tripod collar (sometimes called a tripod bush) on the lens barrel, which will help to balance the load. Tripod collars can be bought separately, but long telephoto lenses are normally supplied with one.

✔ Try to keep the tripod's centre of gravity as low as possible. Only extend the legs as far as you need to, and try to avoid using the centre column whenever possible.

✔ Try to shield the tripod from excessive winds. Using your body as a windbreak can often help.

Filters

Picture Quality

The more filters you place in front of the lens, the less sharp your image will become, so avoid using filters unless they are essential to the picture, and, when you do use them, use as few as you possibly can.

There are literally hundreds of different filters on the market today, of which you are only ever likely to use a few. There are two main reasons for using filters: Firstly, to compensate for the limitations of the film, sensor, camera or lens; and secondly, to enhance certain attributes of the image.

SYSTEMS

There are two main types of filter system: the round screw-in filters that attach directly to the filter thread at the front of your lens and the rectangular filters that are placed in a special holder, which is attached to the filter thread at the front of the lens.

Screw-in Filters

Screw-in filters have become less popular since the introduction of the filter-holder system because they lack flexibility, especially for landscape photography. For example, if you have five different lenses and each has a different filter thread diameter you need five separate filters of each type to accommodate all of your lenses, or at the very least a collection of stepping rings, which can cause vignetting. Not only is this expensive but it adds to the amount of equipment you need to carry around.

One advantage of screw-in filters is that they are made of glass. This means that they tend to provide better optical quality than plastic or resin filters.

Another common use of screw-in filters is for protection; many photographers keep a UV, skylight or clear filter attached to their lens at all times in order to protect the front element. After all a filter is a lot cheaper to replace than a lens. Whether you do this is a personal choice: a poor quality filter will degrade the image but perhaps not as much as scratches on the lens.

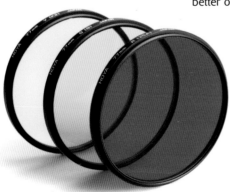

▼ *Screw-in filters are usually made of glass and give excellent optical quality though they are less flexible than the slot-in system.*

Slot-in Filters

The main advantage of the slot-in filter system is that you only need to buy a single filter of each type, irrespective of the size of the lens. The filters slot into a holder that attaches to the front of the lens via a mounting ring with different adaptor rings for different sized lenses. Another factor that makes these systems a better option for landscape photography is that they give you the ability to adjust the positioning of graduated filters. This is impossible to do with a screw-in filter attached directly to the lens, but when positioned in a filter holder the slot-in filter can be moved up or down to accurately align with your composition.

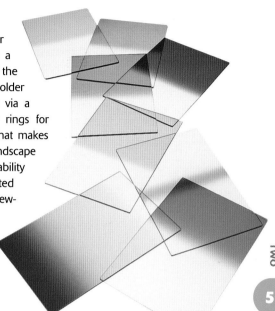

BUYING PHOTOGRAPHIC FILTERS

When choosing a slot-in filter system go for one of the larger versions. The 'professional' series are bigger and can be used with lenses that have a wide angle of view whereas the smaller varieties can cause problems with vignetting, (see page 20).

Size can also be a problem for screw-in filters, as cheaper versions have deeper mounts. If you choose a screw-in filter, make sure that you buy a high-quality one with a thin mount. This will help avoid vignetting.

Filters are usually manufactured from glass, resin or plastic. Because they affect the quality of the light entering the lens buy the best you can afford. Typically, glass is better than resin, and resin is better than plastic. Avoid the gels that are offered by some manufacturers.

Types of Filter

There are four main types of filter used for landscape photography: the 81-series 'warm-up' filters, neutral density (ND) filters, polarizing filters and ultraviolet (UV) filters.

81-SERIES 'WARM-UP' FILTERS

The 81-series of 'warm-up' filters – so called because they add a subtle golden glow to photographs – are much prized by landscape photographers. Light at different times of the day varies in colour, from deep red to blue-white. We've all seen how effective photographs taken at sunrise and sunset can be, an appeal that is caused partly by the warmth of the colours apparent during those times. The 81-series of filters can do one of two things: firstly, they can help accentuate the warmth of colour at sunrise and sunset. Secondly, they can be used to nullify the blue colour cast often visible on film on overcast days or at the height of the summer sun, making your pictures appear warmer in tone.

▶ Compare these three images with each other to gauge the effects of using the 81-series of warm-up filters. Picture **a)** has been taken with no filter attached, picture **b)** was taken with an 81A (minimal effect) warm-up filter, while picture **c)** has a slightly stronger 81B warm-up filter applied.

Learn how to...

USE WARM-UP FILTERS

Be careful not to go over the top with these filters. The effects in the viewfinder can be very seductive but using too strong a tint (81D and above) can give your images an unnatural and unappealing carrot-like intensity. Also bear in mind that some scenes look better with a slight blue colour cast, such as frost, snow and the twilight hours.

>> **SEE ALSO**
Colour of Light, pages 76–7

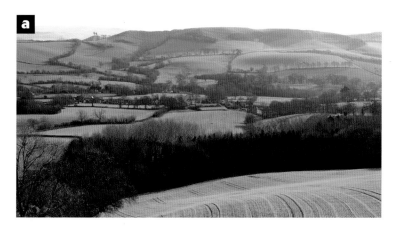

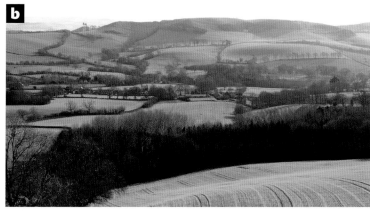

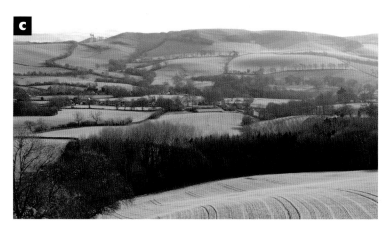

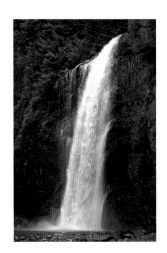

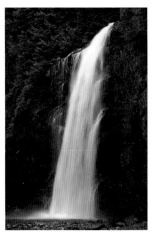

▲ In this scene the light was too bright to allow a slow enough shutter speed to blur the water. So I used a 2-stop neutral density (ND) filter to reduce the level of light entering the lens, which reduced my shutter speed from 1/100sec, top, to 1/25sec, bottom.

NEUTRAL DENSITY FILTERS

A neutral density (ND) filter is one that reduces the intensity of light entering the lens. Because it is neutral it has an equal effect on all colours of the spectrum and therefore there is no noticeable change in the colour of the final image. ND filters are available in two varieties – plain and graduated – and in various strengths.

Plain Neutral Density Filters

Plain ND filters are used to reduce the level of light entering the lens over the entire scene and can be used to gain greater flexibility over shutter speed or aperture settings. For example, if you are trying to blur the motion of a waterfall but the light is too bright to allow a slow enough shutter speed (see pages 100–1), adding a neutral density filter will reduce the level of light reaching the film or sensor and allow you to use a longer shutter speed.

Neutral Density Graduated Filters

Neutral density graduated (NDG) filters are similar to the plain version, however, the degree of filtration is graduated across the filter. This means that the shading

BUYING ND FILTERS

A word of warning when choosing ND or NDG filters. The term 'neutral' implies that the filter has no effect on the colour of light entering through them. In reality, some manufacturers' ND filters can give a cool cast to light, which is not always pleasing to the eye, though it can enhance stormy skies. It is worth checking the results from different makes of ND filters before you buy them, if at all possible.

Learn how to...

USE NDG FILTERS

The best way to use a NDG filter is to set your camera on a tripod and compose the picture. Then, take one meter reading from the sky and another from the foreground area (see pages 91–3). Calculate the difference in f-stops between the two readings, and select the appropriate strength of filter. Now place the NDG filter so that the dark half is covering the lightest area of the scene and, looking through the viewfinder, adjust the filter up or down until it matches the line of the horizon. This is where an SLR comes into its own. Being able to view the scene through the lens allows for some very precise positioning of filters.

of the filter is at its strongest at the top before becoming completely clear at the bottom. These are used to even out the exposure of the scene.

For example, when the sky is far brighter than the foreground, the variation in tone is often too great for the film or sensor to record without losing detail in either the highlights or the shadows. Positioning a NDG filter so that the dark section of the filter covers the brighter area of sky evens out the tones allowing the contrast to fall within the latitude of the film or sensor and produce a photograph with a far more even balance of tones.

There are two main types of NDG filters: hard and soft. The difference is that the transition between the shaded and clear part of the filter is much shorter for a hard NDG than a soft NDG. This means that each is suited to different landscapes. The hard variety are better suited to well-defined horizons such as seascapes, while the soft type will help produce a natural-looking effect when the horizon is broken, for example by trees.

▲ *In this scene, the difference between the brightness of the sky and the foreground varied beyond the latitude of the sensor. I used a 3-stop neutral density graduated filter to even out the tones in the image immediately above and avoid overexposing the sky, like in the top image.*

▲ *For this image, bottom, I have used a polarizing filter at full polarization to remove the distracting reflections, top, from the surface of the water.*

POLARIZING FILTERS

Another essential gadget in the landscape photographer's kit bag is the polarizing filter. Non-polarized light waves vibrate in all planes at right angles to their direction of travel. When light strikes a surface some of it is absorbed and the rest is reflected. This is what gives objects colour, for example a yellow flower absorbs all of the colours of the spectrum apart from yellow, which it reflects giving it the colour we can see.

Sometimes this reflected light becomes polarized, which means that it only vibrates in one plane. This polarized light causes glare and a loss of colour intensity. The same happens when light from the sun is scattered by particles in the atmosphere.

A polarizing filter can be used to reduce the effect of polarized light that is reflected from non-metal objects, this reduces unwanted glare and is particularly useful in landscape photography for deepening blue skies and removing distracting reflections from water. It is also useful for foliage, which reflects a surprising amount of polarized light, particularly when wet.

Learn how to...

USE POLARIZING FILTERS

Polarizing filters are attached to the front of the lens and can be rotated to provide varying degrees of polarization. If you have an SLR simply place your eye to the viewfinder and rotate the front part of the filter. Always rotate your polarizing filter in the same direction as you would to mount it (normally anti-clockwise as you look through the viewfinder). Otherwise you can accidentally unscrew and drop it, when trying to vary the amount of polarization.

BUYING POLARIZING FILTERS

There are two types of polarizing filter: linear and circular. Both have a similar effect on light, but a linear polarizing filter may interfere with your camera's autoexposure and autofocus functions. Buy the circular variety as they work well with all automatic functions.

Polarizing Filters and Exposure

Polarizing filters cut out a lot of light, particularly at full polarization when the effect can be up to two stops. If you are using a meter other than your TTL-meter, or you are using a linear polarizer, then you will need to compensate for this loss of light when calculating your exposure settings. You can use the table below as a guide and I would advise bracketing your shots.

>> **SEE ALSO**
Learn how to... Bracket Exposure, page 96–7

TWO

59

EQUIPMENT

LEVEL OF POLARIZATION	EXPOSURE COMPENSATION
1/4	+ 1/2-stop
1/2	+ 1-stop
3/4	+ 1½-stops
Full	+ 2-stops

Polarizer Tips

Polarizing filters are most effective when used at an angle of 90° to the sun. But try to be restrained when you are using a polarizing filter, as overuse can result in unnaturally dark or unevenly coloured skies.

>> **SEE ALSO**
Colour of Light, pages 76–7

ULTRAVIOLET (UV) FILTERS

While the human eye can't see UV light, photosensitive materials – either film or digital sensors – can. UV light shows in your final image as a blue colour cast and/or an increase in haze in the atmosphere. It is particularly apparent in photographs taken at high altitude, such as from an aeroplane window, or close to the coast. Using a UV filter helps to reduce the appearance of these two problems and makes your images more attractive, giving colours their natural 'punch'.

SKYLIGHT FILTERS

A similar filter to the UV filter is the skylight filter. Skylight, or haze filters as they are sometimes referred to, do the same job as a UV filter except that they have an added pink tint that further warms the image and reduces the blue colour cast discussed above.

Protecting Your Lens

When you buy a lens the store assistant may well try to sell you a UV filter to go with it. In part this is because UV filters can be kept on the lens at all times to protect the front element. I prefer to use them only when necessary, as they constitute an extra piece of glass for light to travel through, which can diminish the overall quality of light reaching the film or sensor.

Digital White Balance (WB)

Many digital cameras offer photographers a choice of different white balance settings. There are two ways to use this feature. Firstly you can use it to counteract the effects of different types of light in order to ensure that colours remain natural. Alternatively you can use it creatively, selecting a different white balance setting from what at first might seem to be the right one.

This is very similar to using colour correction filters, such as warm-up filters. For example, setting the WB to 'Cloudy' has a similar effect to using an 81A warm-up filter, while the 'Incandescent' setting will give a result similar to an 80B series cool-down filter.

Choosing a white balance has some big advantages over using colour correction filters. For a start you have no extra expense of buying a filter set and you have less kit to carry, and even to break. You also don't have to spend ages trying to find which filter is the right one, as you can quite easily experiment using the camera's preview LCD. The lack of an optical filter also helps to preserve the quality of the light as it enters the lens. Perhaps the biggest advantage is that you can tweak the colour temperature later on a computer. If you are at all uncertain of the correct white balance setting, simply shoot in your camera's RAW format. These RAW files can then be quickly and easily altered in the image browser when you download them.

>> **SEE ALSO**
Colour of Light, pages 76–7
Warm-up filters, pages 54–5

TWO

61

EQUIPMENT

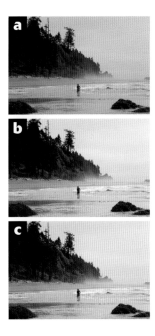

▶ *Compare these three images and note the effect of adjusting the white balance. For the first picture **a)** the camera was set to auto-WB and has produced a cool cast. Changing WB to the cloudy setting **b)** has helped reduce the blue cast and given the scene a warmer tone, similar to the effect created by an 81A warm-up filter. In the third image **c)** the warm effect is further enhanced by setting the WB to shade – an effect similar to that caused when using an 81C warm-up filter.*

Film

A frequently asked question is: 'What type of film should I use?' There is no right or wrong answer to this question because it depends on a number of things, not least the subject you are photographing and your personal preferences. However, there are one or two things that you should consider when choosing a film for landscape photography.

NEGATIVE OR TRANSPARENCY?

Most professional landscape photographers choose to use transparency film because it records greater levels of detail, has more saturated colours and less visible grain than negative film. In part this is due to the single process required to produce a positive image. On the other hand, it can be harder to work with because it has limited latitude and is contrast-rich. Negative film has a greater latitude, meaning that it can record detail in a wider range of tones, but will typically give less 'punchy' results when it comes to the final output. Because it has to go through a dual process – developing and printing – the quality of the final image is often degraded compared with transparency film.

FILM SPEED

How quickly film reacts to light – its speed – is indicated by its ISO rating. Film speeds fall into three categories: slow (ISO 25–64), medium (ISO 100–200) and fast (ISO 400 and above). The faster the film the more quickly it reacts to light but also the more grain becomes apparent. Sometimes, grain can produce very atmospheric images, which may be the effect you are trying to achieve. However, generally grain detracts from the quality and clarity of the image and slower films are a better choice. Most landscape photographers, therefore, prefer to work with a slower film, such as Fuji Velvia 50.

The End Product

Often the choice between transparency and negative will come down to how you want to display your images. If you want to show lots of prints then negative film is probably the most appropriate choice. However, if quality is of prime importance, and you can show your work as slides, only getting a few better quality but more expensive prints made, then slide film is the choice for you.

TWO

63

EQUIPMENT

▼ *The level of contrast in this scene is too great for the film to record detail throughout. Here, the very bright sun has burned out due to overexposure. While the sea has registered black because of underexposure.*

FILM CONTRAST RANGE

Unlike the human eye, which can detect detail with very broad latitude, film only records detail within a limited latitude. A typical negative film has a contrast range of seven stops, enabling it to record detail in tones from near black to almost pure white. However, slide film will only record detail within a range of five stops. This is relevant when you are photographing a scene with many different tones. Those falling outside the contrast range of the film will lose all detail and appear as featureless black shadows or washed-out highlights.

FILM COLOUR RESPONSE

Different films respond to colours in different ways depending on the balance between the red, green and blue layers that form the emulsion. An equal balance will produce a natural colour response close to what you see with the naked eye. Some films are purposefully balanced towards a particular colour, which makes them more suitable to landscape photography. Typically, these are films where the balance is shifted towards green, an example being Fuji Velvia 50.

▼ *Landscape photographers often prefer to work with highly saturated films, such as Fuji Velvia 50, because they produce images with greater 'punch' than films that have a more natural colour response.*

Digital Sensors

Digital photography has brought us new ways of capturing light – via a digital sensor. Unlike film, which is constructed from silver halide, a digital sensor is constructed of millions of photodiodes arranged in a grid pattern, which produce pixels (picture elements).

The resolution of a sensor is given in megapixels (one million pixels), normally to the nearest tenth of a million. Generally speaking, the greater the number of pixels the better the quality of the final image, and as a general rule of thumb any sensor with a resolution greater than 6.0 megapixels will rival that of a professionally scanned slide film.

There is a huge variety of digital cameras and digital sensors on the market. Each performs differently so it would be impossible to discuss them all here. If you are considering buying a digital camera then consult reliable internet review sites such as www.dpreview.com. These should help to give you an idea of how several different cameras within your price bracket compare.

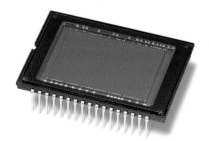

▲ *In digital cameras, the light-capture function of film is replaced by using a sensor such as the one shown above.*

ISO

Like film a sensor's sensitivity to light is measured by an ISO rating. To recap, the lower the ISO the less sensitive the sensor, while the higher the ISO the more sensitive to light the sensor becomes. Unlike film the ISO of the sensor can be altered from shot to shot, albeit within certain limits that differ for each camera. Beware of setting ISOs higher than ISO 400 as the increased sensitivity can lead to noise (see page 66) becoming apparent in the final image.

NOISE

Digital noise occurs because of random false signals sent by the sensor and has a similar appearance to the grain of photographic film. As with grain, the bigger the enlargement of the original image the more noticeable the noise becomes. The effect of noise is increased by two factors: high ISO settings and long exposures.

\>\> **SEE ALSO**
Shutter Speed, pages 100–1

◄ Digital sensors suffer from noise, caused by heat and/ or amplification. This degrades image quality, below left, in much the same way as grain can ruin a film image. Using a slow ISO setting – 100 or 200 – and using the noise-reduction facility with extended exposures will help to reduce digital noise, top left.

As explained above, setting a high ISO – 400 or above on most cameras – will lead to unwanted noise. However, while lower ISO ratings produce less noise they do necessitate longer exposures. The longer a sensor is exposed to light, the more obvious noise becomes. Some cameras come with a 'noise reduction' option specifically for use in long-time exposures and I highly recommend using it when your shutter speeds exceed one second.

Choosing between using high ISO settings or long exposures depends partly on the style of image you wish to capture and partly on a balancing act between the levels of high-ISO and long-exposure noise generated. Where that balance lies depends on the model of camera you use, so it is worth experimenting with combinations of shutter speed and ISO and monitoring the levels of noise that are visible in the final image.

COLOUR SPACE/MATRIX

Some digital cameras also allow you to alter the colour space (often called colour matrix) that they work in. This is like changing the type of film you're using, it also helps to ensure colour consistency between digital cameras, computer monitors and printers around the world. There are two main colour space profiles: Adobe 1998 and sRGB. Adobe 1998 is generally used for professional reproduction such as magazines, newspapers and books. The sRGB colour space is more useful for displaying images on screen, such as when posting them on the internet.

Some cameras offer a range of sRGB settings that record tones suitable for different subjects. For example some colour spaces produce neutral tones suitable for portrait purposes, while others give higher colour saturation to give landscape images more punch.

If you intend to carry out any post-capture computer manipulation then choose the Adobe 1998 profile, however if you want to print the image as it was captured in-camera choose the relevant sRGB setting.

>> **SEE ALSO**
Digital Enhancement, pages 122–35

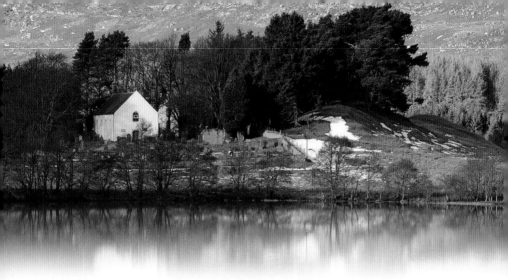

THREE **LOCATION**

Being in the right place at the right time is everything in landscape photography. Knowing when and where that is, however, can sometimes be harder than it seems.

Good Locations for Photography

Contrary to popular belief, professional landscape photographers don't just wander the planet hoping to bump into spectacular photo opportunities. They simply don't have the time. Instead, their movements have to be well planned and deliberate.

FINDING GOOD LOCATIONS

>> **SEE ALSO**
Useful Information, page 136

Spotting good locations is all about research. The best place to start is the local library or a bookshop, where you can flick through the pages of travel guides for inspiration. A similar idea is to look through travel brochures. Many photographic magazines also have sections dedicated to revealing hot spots for photographers, including all you need to know about planning a trip. If you are already at a location, then visit a souvenir store and take a look at the postcards and

calendars. Often, they will reveal many suitable locations for landscape photography. And, of course, there are the vast numbers of pages on the Internet, which has become an invaluable research tool.

READING THE LANDSCAPE

Sometimes, a scene may have potential but the immediate weather or light conditions aren't conducive to great photography. If this is the case, you should try to identify characteristics in the land that would make a good subject if the conditions were better. Look for graphic elements that could be exploited for their patterns and colours. And don't just think about the present, but consider what the scene would look like at different times of the year, for example, at the peak of Autumn. If you do find a scene with lots of potential, make a note in a diary or logbook as a reminder to yourself. Looking at the landscape in this way will greatly improve your photographic productivity, which can be paramount if you have to divide your time between your hobby, a full-time job, family and social life.

>> **SEE ALSO**
Elements of Design,
pages 108–9

▼ *I first noticed this scene on a dull, overcast day around noon. However, I noted its potential and returned on a clearer day, earlier in the morning to take this beautiful landscape shot.*

69

◄ *Choosing to photograph this scene during autumn meant that there were some fallen leaves on the rocks that provided some foreground interest.*

You and the Law

As a landscape photographer you owe a duty of care to the environment. Be aware of local by-laws and polite notices from landowners, and try to minimize your impact on the land.

FIND AND USE TIDETABLES

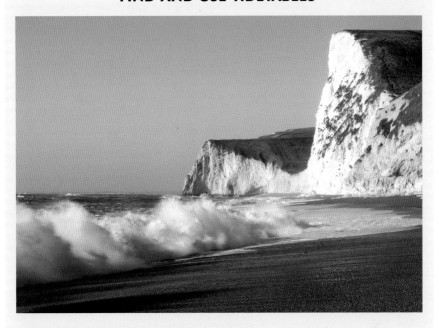

When photographing the coast it's a good idea to check the times of the tide, since the landscape can look quite different when the tide is in or out. Tides can also be very dangerous and many people have been stranded and drowned when the tide came in quicker than they expected, so check locally to see if there are any peculiarities that might catch you out. Worldwide tide information is available from the UK Hydrographic Office at www.ukho.gov.uk.

▲ *Coastal scenes differ greatly depending on the tide. Check local papers or the website mentioned below to make sure you're in the right place at the right time.*

Predicting the Weather

There's nothing more de-motivating than getting all geared up for a day in the field, waking before sunrise for an early start, only to find that the weather is against you. Learning to read a weather forecast can save you time and a huge amount of disappointment. You don't need to be an expert; just learning some of the basic weather patterns will help enormously.

>> **SEE ALSO**
Useful Weather Websites
in *Useful Information*,
page 136

Isobars and Pressure

The lines on a weather map are known as isobars and they join points of equal pressure, which are marked numerically. Isobars identify particular features such as ridges or anticyclones (areas of high pressure) and troughs or depressions (areas of low pressure).

Each feature is associated with different kinds of weather. In areas of low pressure (a depression, or a trough) air is rising. As it rises and cools, water vapour condenses to form clouds and sometimes precipitation. Consequently, the weather in a depression is often cloudy, wet and windy. On the other hand, in areas of high pressure (anticyclones or ridges) winds tend to be light and the air is descending, indicating a clear day in summer but a foggy day in winter.

The strength and direction of the wind can also be gauged from isobars. In the northern hemisphere wind normally blows clockwise around areas of high pressure and anti-clockwise around areas of low pressure. While in the southern hemisphere wind normally blows anti-clockwise around areas of high pressure and clockwise around areas of low pressure. The strength of the wind can also be gauged by looking at the isobars: the closer together they appear, the stronger the wind will be.

Fronts

The boundary between two different types of air mass is called a front. There are three types of front: warm, cold and occluded.

Warm fronts are identified by red semicircles facing the direction in which the front is moving. They bring heavy clouds and eventually prolonged rain with strong winds. Once this has passed, the weather will typically be milder, but still overcast with some light rain.

A cold front often brings heavy showers and strong winds that give way to brighter conditions with occasional showers. Cold fronts are identified by blue triangles facing the direction in which the front is moving.

Occluded fronts occur when a cold front overtakes a warm front, and have similar – although less severe – characteristics to a cold front. They are marked by a thick line with alternate red semicircles and blue triangles facing in the direction of travel.

KEY

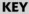

Warm Front

Cold Front

Occluded Front

H = High Pressure
L = Low Pressure

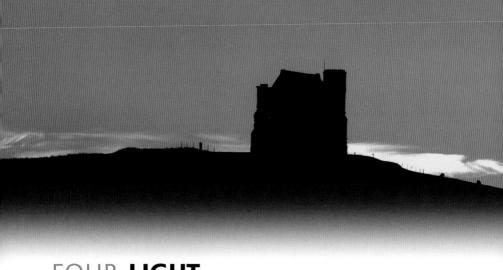

FOUR **LIGHT**

Light is the most important element in photography and good light can make the difference between a great landscape picture and a poor one. So here is a short guide to the different characteristics of light.

Soft and Hard Light

SOFT LIGHT

Light is said to be 'soft' when it is scattered by a diffuser, for example clouds on an overcast day. Soft light is low in contrast, producing shadows with faint edges. Because of this it can work against landscape photographers, by rendering textures indistinct. However, high-contrast subjects, such as waterfalls, benefit from soft lighting as correct exposure becomes easier.

HARD LIGHT

Non-diffused light, direct from the sun, is said to be 'hard' because it accentuates contrast, forming shadows with well-defined edges. This high level of contrast helps to create a sense of texture and depth within a photograph, and is often preferable for this reason. However it can make correct exposure more difficult.

▶ *Soft light from an overcast sky has reduced the level of contrast in this woodland scene. Instead I have used colour as to provide a contrasting factor.*

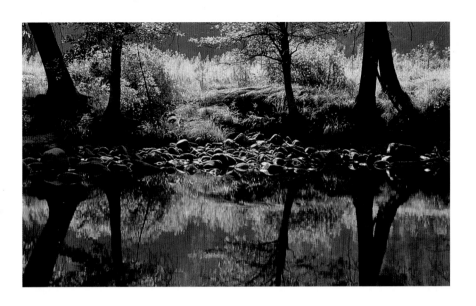

▲ *Light can be hard (as above) or soft in quality and will affect the mood evoked by your images. Always keep an eye open for good photographic lighting and avoid lighting that creates flat images.*

Colour of Light

Colour Management

There are a variety of ways to manage the colour of light, either to enhance or to neutralize its nuances. If you are using a digital camera make sure that setting the white balance to auto does not result in the camera neutralizing the effect that you are trying to capture.

▼ *Hard light from direct sunlight on a clear day has helped to give this image its form endowing it with an almost three-dimensional appearance.*

The colour of light changes throughout the day, depending on the weather and the position of the sun in the sky. At sunrise and sunset, when the sun is at an acute angle to you the light has a warm feel, with reds, oranges, golds and yellows prevailing. As the sun rises in the sky, the colour changes to a cooler blue and, at its peak, white light. Our eyes naturally compensate for these colour shifts, but film and digital sensors record it and, for this reason, you find landscape photographers most active during the early morning and late afternoon – the so-called 'golden hours'.

SUNRISE AND SUNSET

Sunrise and sunset times differ throughout the year. The sun moves surprisingly fast, and you may only have a few minutes to capture a photograph in particular lighting. Ideally you should be in position having already planned and composed your shot. To save you getting up too early or, worse still, too late, check the times of sunrise and sunset in your local paper. Worldwide information is available from www.sunrisesunset.com

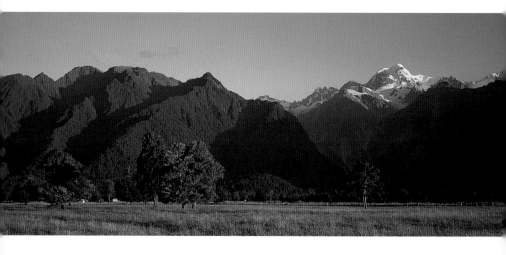

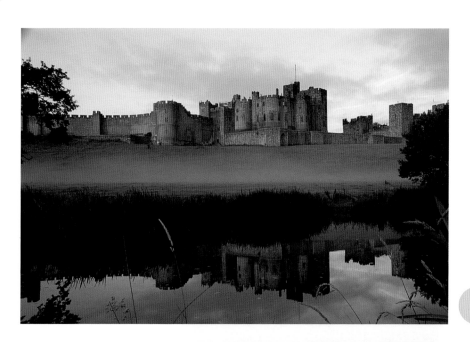

▶ *Sunrise and sunset are often considered the 'golden hours' for landscape photographers, partly because of the colour of light at these times of the day.*

Direction of Light

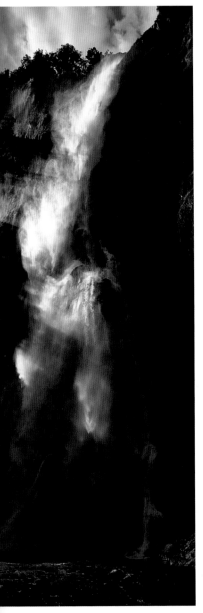

The direction of light will greatly affect how a scene is recorded on film or digital sensor. From directly above and in front of the subject the light will appear flat and lacking in contrast. This is the worst time to photograph the landscape, as your images will lack depth, appearing two-dimensional.

SIDE LIGHTING

Lighting coming from the side of the subject will create shadow areas that accentuate texture or help distinguish between the sides of a three-dimensional object. Side lighting creates contrast and shadows, which help to give your pictures a sense of depth, making them appear more three-dimensional.

◄ ▼ *Lighting from the side helps to create shadows accentuate the contrast between tones. Shadows and contrast give images form and recreate depth in an otherwise two-dimensional print.*

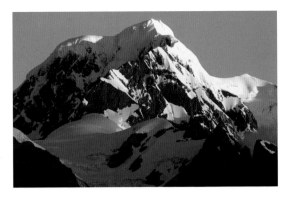

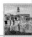
✔ ▶ To create a sense of depth, position the camera so that the sun is falling on the subject from the side. Alternatively, if you don't want to change the position of the camera wait for a time of day when sunlight hits the subject from the side.

✔ Avoid photographing during the middle of the day when the sun is directly overhead.

✔ Soft lighting is ideal for photographing high-contrast subjects such as waterfalls where the water can appear as a bright white, while wet rocks often appear black.

✔ Hard, direct lighting will create contrast, helping to accentuate the depth and form of a subject.

✔ Early morning and late afternoon are often considered the best times for landscape photography because the light has a warm feel to it.

✔ ▼ Backlighting can be used to create silhouettes and strong graphical images, (see pages 80 and 105).

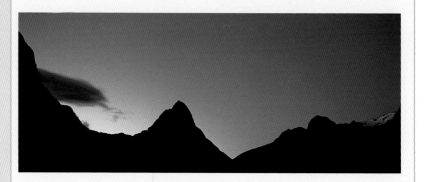

FOUR

79

LIGHT

BACKLIGHTING

Warning

Be extremely careful
when backlighting
subjects. Never point
your lens directly at the
sun as it can damage
both the camera, the
film or digital sensor
and your eye.

Backlighting can be used to exploit the differences in reflectivity. For example, water, when backlit, appears wet and liquid, as you would expect. However, when lit by from the side or above it appears more as a solid mass. Creatively, backlighting can be used to produce silhouettes, which make powerful graphic statements, see page 105.

One thing to be aware of when using backlighting is the possibility of lens flare caused by light falling directly onto the lens. A lens hood will help to lessen the effects of lens flare, as will buying a good-quality lens in the first place and keeping it clean.

▼ *Depending on how you expose the scene, backlighting will create silhouettes that produce powerful graphic statements.*

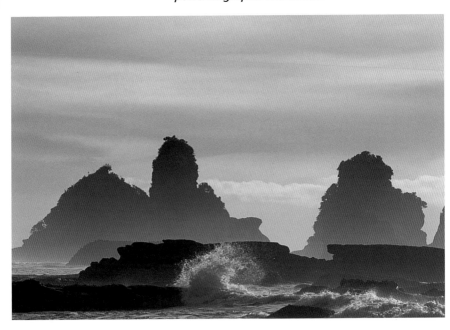

Try out the following exercise to visualize how different lighting effects changes the way the camera interprets the subject you're photographing.

1 Set up a small indoor studio, as illustrated below. Use an angle-poise lamp as your light source.

2 Find an object to photograph. Something with a strong form and visible texture, such as an orange, would be suitable.

3 Start with the light source in front of and slightly above the object (around 45°). Take a picture.

4 Now, keep changing the direction and angle of the light source, taking a picture for each change.

5 Review your images and notice how the appearance of the object changes depending on the direction and angle of lighting. You can now apply this knowledge when photographing the landscape.

6 Repeat the steps above using two lamps, in order to understand how having two light sources, such as the sun and reflected light from water, affects texture and form.

FOUR

81

LIGHT

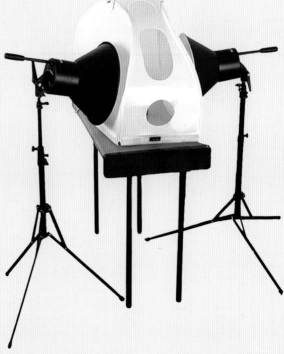

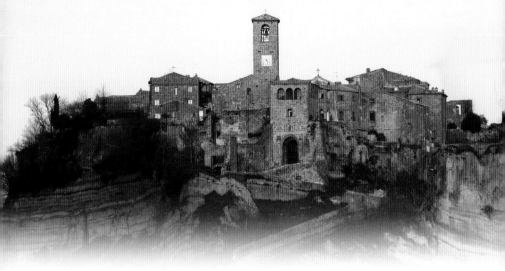

FIVE **FOCUSING**

Most of the time your landscape pictures need to be sharp from foreground to background. As this can cover an enormous distance, it is important to know how to manage focus in order to achieve this.

The Point of Focus

>> **SEE ALSO**
Lenses, pages 42–7
Aperture, pages 98–9

A lens only has one point of focus, measured in feet or metres. If you focus on a point that is, say, 90 feet (30 metres) from the camera then anything that is exactly 90 feet (30 metres) away will be in focus. Any subject that is closer or further away will be technically out of focus. However, it may appear to be sharp depending on the depth of field.

DEPTH OF FIELD
Although a subject may be technically out of focus it may still appear sharp if the degree to which it is out of focus is undetectable to the human eye – this is known as the depth of field. While it is impossible to focus on all the different areas of a scene, it is possible to render the whole image sharp if you can obtain enough depth of field to cover everything in the picture space.

Three things determine depth of field: aperture, focal length and camera-to-subject distance. All three of these elements work together to give the final effect, which determines how much foreground and background detail of your images remains apparently sharp.

Aperture
The narrower the aperture the greater the depth of field will be. Conversely, the wider the aperture the less depth of field you will have to work with.

Focal Length
The higher a lens's focal length is the less depth of field there will be. Conversely lenses with shorter focal lengths offer relatively more depth of field. Along with

▼ *Landscape pictures usually need extended depth of field to succeed. This is particularly the case when you include foreground interest, such as the boulders in the scene below.*

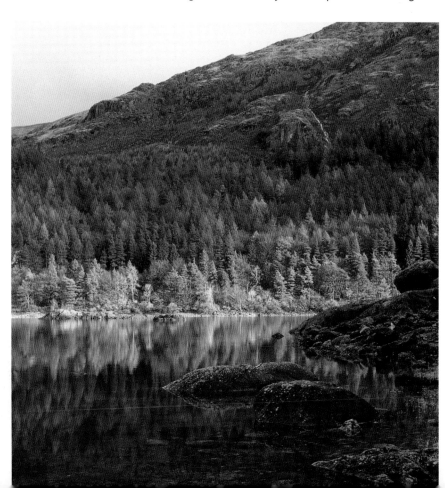

Note

Measuring depth of field isn't an exact science. A number of factors come into play including the size of the final print and the distance it is viewed from. When most figures are given for depth of field they are based on a 10x8in print viewed from at least one foot (30cm) away.

>> **SEE ALSO**
Useful Information, page 136

the wide angle of view this is one of the reasons that wideangle lenses have become so popular with landscape photographers.

Camera-to-subject Distance

The further away your subject is from the camera then the greater the depth of field will appear. For many landscapes you will be a long way from your subject, however, if you have a subject in the foreground, such as boulders or flowers, then you will need to remember that their presence will affect how you manage the depth of field.

MEASURING DEPTH OF FIELD

While it is useful to have an idea of the different effects on depth of field that aperture, focal length and camera-to-subject distance have, it helps to get a more precise idea in each situation. Firstly, some cameras have a depth of field preview function. This works by stopping the lens down so that you can actually see the effects of your chosen aperture. This is perhaps the most accurate way of measuring depth of field but has its limitations because when you stop down the lens you reduce the amount of light reaching the viewfinder, making it difficult to see the scene you're photographing. This technique needs practice but is worth persevering with, as it can give great results.

Most prime lenses come with a depth of field scale on the lens barrel. This indicates the depth of field for any given aperture and focus setting. While this system works well on prime lenses, zoom lenses don't have this option because the depth of field changes with every adjustment in focal length.

It is also possible to calculate the depth of field for any focal length lens and for all aperture settings, and these calculations are given in depth of field charts, which can often be found within the lens's instruction manual. Alternatively, a number of websites offer depth of field and hyperfocal distance calculators.

Have a go at this simple exercise to see how depth of field works.

1 Attach your camera to a tripod. Compose a picture where there is a combination of foreground, middle ground and background interest.

2 Set your camera to aperture priority mode, (if your camera doesn't have this function use the manual setting and meter accordingly), and select the widest available aperture.

3 Focus on the subject in the middle of the picture and take a photograph.

4 Keeping the same composition and without moving the camera, adjust the aperture by one stop, (remembering to make the appropriate reciprocal change in shutter speed if using manual mode), and take another picture. Repeat this step until you reach the smallest aperture.

5 Review the results and see how the depth of field changes in each picture.

▼ *Maximizing the available depth of field is often critical to the success of a landscape picture.*

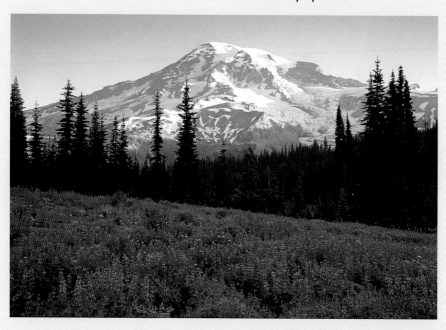

Hyperfocal Focusing

Hyperfocal Focusing

In landscape photography hyperfocal focusing is a useful tool for ensuring that everything from important foreground elements all the way to the horizon is acceptably sharp.

While the name might sound complex, in practice hyperfocal focusing is relatively simple. Simply put, the hyperfocal distance is the point of focus that gives the maximum depth of field for a given situation.

The method of hyperfocal focusing makes use of the fact that two thirds of the depth of field always lies behind the point of focus and one third in front of it. This means that as a rule of thumb you can find the hyperfocal distance by focusing on infinity (∞) then depressing the depth of field preview button to identify the closest point that is still in focus. Then refocus the lens on this point (the hyperfocal distance), the depth of field will now extend from halfway between the camera and the hyperfocal distance all the way to the horizon. You can also calculate the hyperfocal distance using the depth of field scale on the side of your lens if it has one. Simply set the depth of field marking to the correct aperture, then focus the lens so that the infinity symbol (∞) is aligned with the outer depth of field marker.

▶ In figure **a)**, with the lens focused on infinity (∞), depth of field extends from the dotted line to infinity (∞). By adjusting focus to the nearest plain of sharpness (the hyperfocal distance, indicated by the dotted line), depth of field is extended from infinity to halfway between the hyperfocal distance and the camera in figure **b)**.

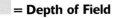 = Depth of Field

Avoiding Image Blur

Even if your pictures are well focused and the depth of field gives front to back sharpness, images can still appear blurred. Camera movement during exposure is often the cause. This camera shake, as it is usually called, can be caused by a number of things from poor camera technique to the weather. So here's how to avoid it.

Shutter Speeds for Handholding a Camera

It is a commonly held rule in photography that the slowest shutter speed at which a camera can be handheld is the reciprocal of the lens's focal length. This is because an image's magnification is typically higher with longer focal lengths, and therefore the effect of camera shake is increased. For example a 300mm lens needs a shutter speed of at least 1/300sec, while a 50mm lens would need a shutter speed of at least 1/50sec. While this is a useful guide it is unreliable in practice as it ignores too many external factors, such as film speed (ISO setting) and the physical size of the lens. There really is no hard and fast rule other than to use a tripod whenever you can.

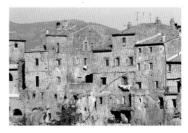

▲ *To avoid image blur, top, always use a tripod, or similar solid support, to stabilize your camera. When used properly, (see pages 50–1), tripods help to ensure pin sharp pictures every time, immediately above.*

Learn how to...

HANDHOLD A CAMERA

If you have to handhold your camera, keep your feet slightly apart with your weight balanced evenly and tuck your elbows into your body for extra stability. When you're ready to take the picture, take a deep breath and breathe out slowly, pressing the shutter release button as you do so. As with tripods, the lower to the ground you can get the more stable you will be. If possible find some form of support to lean against, such as a wall or post.

MIRROR LOCK-UP

All SLR cameras have a reflex mirror that flips out of the way just before the shutter curtain opens. This action causes vibrations in the camera that can result in camera shake, particularly at very slow shutter speeds or at very high magnifications. Some cameras have a mirror lock-up facility, which locks the mirror in the up position before the shutter is released, thereby stopping these vibrations. In some digital SLR cameras this function is often referred to as anti-shock and, although it works in a slightly different way, it achieves the same thing.

ANTI-VIBRATION TECHNOLOGY

Many manufacturers have introduced various forms of anti-vibration technology under a variety of different trademarks, such as: Image Stabilization (Canon), Vibration Reduction (Nikon), Optical Stabilization (Sigma) and Anti-Shake (Konica Minolta). There are two main types: those that move an optical element of the lens to counteract image shake, and those that move the sensor in a digital camera. While, manufacturers advertise that this technology allows photographers to handhold cameras for shutter speeds up to three stops slower than they would otherwise be able to, it is still no substitute for a tripod. It also makes lenses more expensive so concentrate on buying one with good-quality optics instead.

▶ *Anti-vibration lenses help to reduce the effects of camera shake. However, they have been designed principally for forms of photography, such as press and wildlife photography where use of a tripod is often impractical. This doesn't apply to landscape photography, where a tripod is always the best bet.*

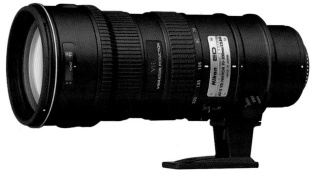

Working with Autofocus

When operating the camera in autofocus mode it's important to make certain that the autofocus sensor is focusing on the correct place. Ensure that you have selected the correct focusing bracket that is placed over your intended subject. Alternatively, utilize the AF-lock function – if your camera possesses it – by focusing on the subject then while semi-depressing the shutter-release button or pressing the AF-lock button recompose the image.

Normally it is far better to rely on manual focus, as this will give you a lot more control over your image. If your camera offers an in-focus indicator (most modern SLRs do) you can use this to check that your manual focusing agrees with the camera's autofocus system.

▼ *When using autofocus make certain you have selected the appropriate target sensor for the subject. Otherwise, you may find your subject is out of focus.*

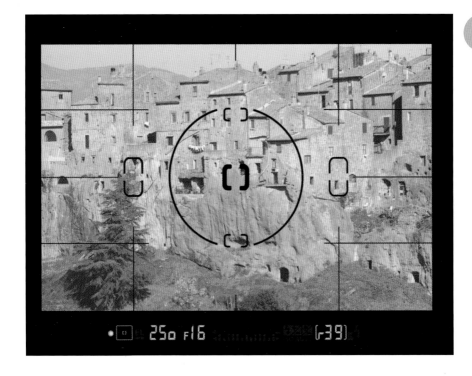

SIX **EXPOSURE**

The key to good exposure is to get just the right amount of light for the correct length of time, given the sensitivity of the material, to record the scene as you interpret it.

Measuring Light

>> SEE ALSO
Film, pages 62–4.
Digital Sensors, pages 65–7.

The quantity of light reaching the film or sensor, (controlled by the aperture), and the length of time the shutter remains open (the shutter speed) will determine your exposure. What constitutes a correct exposure depends on the sensitivity of the film or sensor. Allowing too much light to strike the film or sensor will result in overexposure – a lack of detail in the highlight areas. Allowing too little light to strike the film or sensor will result in underexposure – a lack of detail in the shadow areas.

Light can be measured in one of two ways, either by assessing the brightness of the scene (reflected light), or the amount of light falling on the scene (incident light). The light meter then calculates an exposure value, which is translated into a combination of aperture and shutter speed, in relation a particular ISO.

METERING

Incident light meters have limited use for landscape photography as you have to place the meter in the same lighting conditions as the subject. However, reflected light meters work by assessing the level of light reflected from the subject, which makes them perfect for landscape work. Often they are built into the camera with readings provided in the viewfinder and on an LCD panel. Most modern cameras incorporate a through-the-lens (TTL) meter that measures the amount of light actually entering the lens.

However, because the reflected light meter will be influenced by both highlights and shadows, as well as mid-tone subjects, exposure calculations are often complex. In modern cameras, TTL meters now provide systems to help overcome this problem.

Multi-segment Metering

A multi-segment metering system takes several independent readings from different areas of the frame and calculates a meter reading based on the results. In some camera systems these findings are first compared to a database of 'real-life' images to detect the closest match, and some also incorporate subject distance into the equation. Multi-segment metering is great for relatively normal scenes and will get the exposure spot-on nine times out of ten. However, if you want the ultimate in control then you should use the spot metering function.

Centre-weighted Metering

Centre-weighted metering measures the light across the entire scene but weights the reading towards the central portion of the frame, which is usually indicated by a circle in the middle of the viewfinder. Normally the central circle is given about a 75% weighting while the rest of the frame has about 25%.

Spot Metering

In spot metering mode, the TTL meter takes a reading from a tiny section of the scene – usually an area around just 3–5°. This enables precise metering of specific areas

Handheld Meters

It is possible to get handheld reflected light meters that offer a 1° spot metering facility, which ensures great accuracy when measuring light in variable conditions. Many landscape photographers prefer to work with a 1° spot meter for this reason.

providing the greatest level of control over your exposure settings. Spot metering is an ideal solution when working in high contrast conditions and where the intensity of light varies considerably throughout the frame.

◀ *Multi-segment metering systems use a pattern of exposure sensors to calculate the correct exposure taking into account the whole scene.*

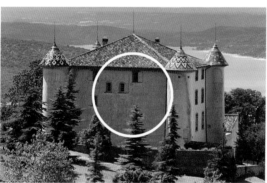

◀ *Centre-weighted metering systems take brightness information from the whole scene but weight the exposure calculation towards the central portion of the frame.*

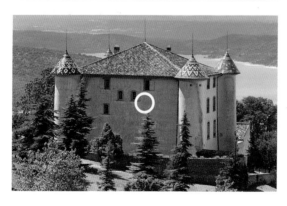

◀ *Spot metering systems assess the level of brightness from a minute area of the frame (often as little as 1°) and give an exposure calculation accordingly.*

HOW A LIGHT METER WORKS

All light meters are calibrated to give an exposure value for a mid-tone subject, that is a subject that reflects 18% of the light falling on it. When you meter a subject the light meter will give a reading that will let you record it as a mid-tone subject. That's fine if the subject is mid-tone. But what if it's not?

Say you are photographing a winter landscape where the ground is covered in snow. You set your camera to auto-TTL metering and take a picture. When it's developed the snow looks grey and dull (bottom), nothing like the brilliant white you remember. This is because the camera's meter saw it as grey – 18% grey to be exact. Now, take another picture, this time opening up your exposure (adding more light) by two stops. You will see that the snow has come out looking exactly as you remembered it – bright, brilliant white (top).

The exact opposite occurs when photographing subjects that are black. This is because a camera will underexpose light subjects to make them darker and overexpose dark subjects to make them lighter – all the time trying to achieve a tone equal to 18% grey. In order to compensate for these automatic exposure calculations you must tell the camera to do the opposite of what it has just done. So, when photographing subjects that are lighter than mid-tone, where the camera has underexposed the image, you must tell it to overexpose by dialling in positive exposure compensation or by manually increasing the exposure. If you are photographing a subject darker than mid-tone, where the camera has overexposed the image, you must tell it to underexpose by dialling in negative exposure compensation value or manually decreasing the exposure. While exposure values are often referred to in terms of grey tones the same rule applies for any colour in the visible spectrum.

USE EXPOSURE COMPENSATION

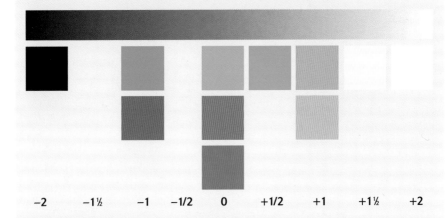

-2 -1½ -1 -1/2 0 +1/2 +1 +1½ +2

▲ *The above diagram gives an indication of the various levels of exposure compensation required for different colours and tones of grey. These have been calculated using my own camera and may vary slightly from camera to camera. It's advisable to run your own tests for complete accuracy.*

When you take a meter reading you must ask yourself the question: 'Is the subject I am metering mid-tone, lighter than mid-tone or darker than mid-tone?'

If the subject is mid-tone then the given meter reading will provide a technically accurate result. However, if the subject is lighter than mid-tone then you must add light (increase the exposure) and if the subject is darker than mid-tone then you must subtract light (decrease the exposure). That's all very well but how do you know how much exposure compensation to apply? The secret is in learning to see colour in terms of grey, just as most meters do. Practice by taking a grey card out with you and comparing it to different colours that you see. Then, using your camera's exposure compensation function, dial in the appropriate amount of positive or negative compensation in order to reproduce the colour faithfully.

If you want to put this theory into practice then try this simple test.

1 On an overcast, dry day place three pieces of card on the ground: one white, one black and one medium grey.

2 Set the camera's exposure mode to auto and photograph each piece of card separately, ensuring they fill the entire frame.

3 When you review the results you will see that each photograph appears the same in tone – medium grey.

4 Now repeat the test but this time dial in +2 exposure compensation when photographing the white card and dial in −2 exposure compensation when photographing the black card. Photograph the grey card at the indicated reading.

5 When you review this second set of pictures you will notice that the tone of each piece of card looks in the picture as it did in real life.

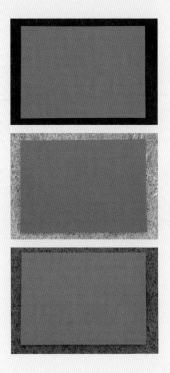

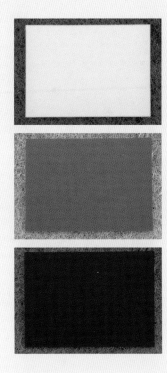

BRACKET EXPOSURE

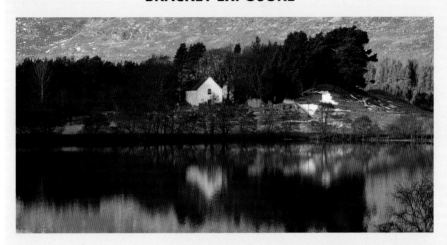

However hard you try and however much care you take when calculating exposure, it is sometimes impossible to get it spot on. Many factors can influence exposure, such as very bright sunlight reflecting off shiny surfaces, constantly changing light conditions like those you will encounter on days where broken clouds fill the sky, and subtle variations in a subject's tonality.

Another factor that is outside of your control, is that film manufacturers and processing labs operate to tolerance levels that could make a difference of up to half a stop in your exposures. For all of these reasons and more, an important technique to learn is bracketing your exposures. Bracketing involves taking more than one photograph of the same scene at varying exposure values above and below your initial exposure setting. Typically, the variance should be around a third or a half of a stop. On rare occasions, when you are really uncertain, you should bracket by plus or minus one stop.

Note

When using automated bracketing remember to turn this function off if you no longer want to bracket images. Otherwise you will end up with accidentally over- or underexposed photographs.

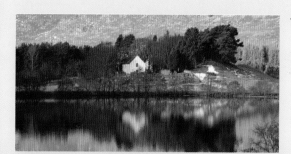

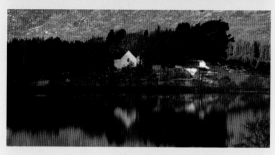

◀ *Bracketing images will produce more than one picture of the same scene but at slightly varying exposure settings. It is a technique used to ensure an accurate exposure is achieved in very complex lighting conditions. When you first begin taking landscape photographs this is a useful way of learning about the different effects of under- and overexposure.*

There are three ways of bracketing your images: automatically, using compensation, or manually. Many cameras offer automated bracketing. This allows you to set how far apart you want your brackets to be and in some cases select how many shots there are in the bracketed sequence. In shutter priority mode it will vary the aperture, and in aperture priority mode it will vary the shutter speed, in other modes a combination of aperture and shutter speed is normally changed.

You can also use the exposure compensation dial to dial in values yourself, which gives you a little more control although it is less convenient.

Finally in manual mode you can choose to bracket how you like. Either by altering the shutter speed, the aperture or a combination of the two.

Controlling Exposure

To achieve faithful exposure the camera provides you with two basic controls: aperture and shutter speed. Both controls can be adjusted independently. Each, however, is interdependent on the other and understanding their relationship to each other and to the film or sensor's sensitivity is the key to understanding exposure control.

The standard measurement for exposure is the stop. Any change in aperture or shutter speed is referred to by however many stops it increases or decreases exposure. For example a change in lens aperture from f/8 to f/11 is considered a one-stop decrease in aperture and altering shutter speed from 1/125sec to 1/250sec is considered a one-stop increase in shutter speed.

APERTURE

The aperture controls the amount of light reaching the film or sensor at any one time. It is a hole of variable size that is located within the lens, and changing the size of the aperture alters how much light is allowed through.

All camera lenses are calibrated to the same scale of measurement known as f-stops. These can be seen on the lens's aperture ring (if it has one) and are shown in the LCD panels of modern cameras. The range of f-stops varies depending on the lens but always forms part of the same scale, illustrated in the table, left. Some cameras and lenses also allow you to set half or even third of a stop settings, for example f/9.5 is half a stop narrower than f/8 and half a stop wider than f/11.

Each f-stop is a ratio of the diameter of that particular aperture divided by the focal length. For example, if the focal length is 200mm and the diameter of the aperture is 25mm, the f-stop equals 25/200, or 1/8 (written as f/8). This is why the larger the f-stop selected the smaller the aperture is. Increasing the aperture by one full stop will double the amount of light reaching the film or sensor. Reducing the aperture by one full stop will halve the amount of light reaching the film or sensor.

f-STOP INDEX
f/1.4
f/2
f/2.8
f/4
f/5.6
f/8
f/11
f/16
f/22
f/32
f/45

Controlling exposure via the aperture will affect depth of field. The larger the aperture (small f-stops) the less depth of field you will have to work with, while reducing the aperture (large f-stops) will increase the available depth of field. This will impact on how a scene appears in the final image, which must be taken into account when setting your exposure values relative to your composition.

>> **SEE ALSO**
Depth of Field, pages 82–6
Design, pages 106–19

◀ ▼ *Aperture controls the depth of field. Small apertures (large f-stops) increase the depth of field, left, and both the foreground and the background appears sharp, while large apertures (small f-stops) reduce depth of field, below, blurring foreground and background detail.*

>> **SEE ALSO**

Try it out... Combining the Elements of Composition, page 113.

SHUTTER SPEED

The length of time that the shutter is open and exposing the film or sensor to light is known as the shutter speed. This is measured in fractions of seconds or – for longer exposures – whole seconds. Most cameras have pre-set shutter speeds between 30 seconds and 1/2,000sec (or faster), with an additional setting known as the B(ulb) setting or T(ime) setting. In the B setting the shutter remains open so long as the shutter-release button is depressed. To operate a camera in the T setting you simply press the shutter-release button once to open the shutter and then once to close it. Both of these settings allow shutter speeds longer than the camera's longest pre-defined setting. More sophisticated modern cameras have a greater range of shutter speeds, as fast as 1/16,000sec at the time of writing. A table of common shutter speeds (seconds or fractions of a second) is shown left.

As with aperture, a full one-stop change in shutter speed will either double or halve the quantity of light passing through to the film or sensor. For example, increasing the shutter speed from 1/125sec to 1/250sec will halve length of time the shutter is open, and thereby halve the quantity of light. Correspondingly, decreasing the shutter speed from 1/250sec to 1/125sec will double the length of time that the shutter is open, thereby doubling the quantity of light. Most modern cameras allow you to set more precise shutter speeds than the whole-stop changes in the table. Many allow either settings to be made in either half or third stops. For example 1/750sec is half a stop faster than 1/500sec and half a stop slower than 1/1,000sec.

Controlling exposure via shutter speed gives you control over how you depict movement in your images. A fast shutter speed, for example, will tend to freeze movement, while a slow shutter speed will create blur giving a greater sense of motion.

SHUTTER SPEEDS

SHUTTER SPEEDS
30 seconds
15 seconds
8 seconds
4 seconds
2 seconds
1 second
1/2sec
1/4sec
1/8sec
1/15sec
1/30sec
1/60sec
1/125sec
1/250sec
1/500sec
1/1,000sec
1/2,000sec
1/4,000sec
1/8,000sec
1/16,000sec

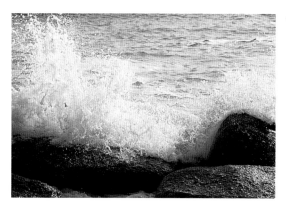

◄ *Shutter speed controls how motion is captured in a photograph. A fast shutter speed will freeze motion, as shown in this picture of waves crashing against the shoreline.*

▼ *A slow shutter speed blurs the appearance of motion, creating a more ethereal effect, as can be seen in this picture of water tumbling over rocks as it cascades down a mountainside.*

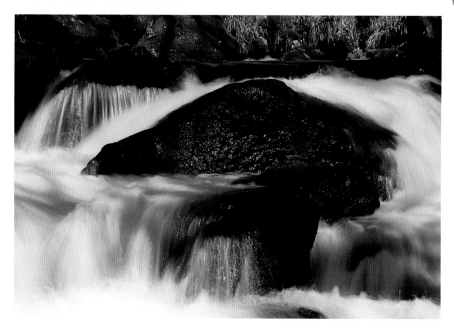

USING BOTH CONTROLS TOGETHER

Making faithful exposures requires you to understand the nature of the relationship between the two main exposure variables and the ISO setting. In order to achieve the results you want you will have to work creatively within the limitations of this relationship.

When not enough light reaches a film or sensor – at a given ISO rating – underexposure will occur. To correct this you can either increase the aperture or decrease the shutter speed, both of these steps will increase the level of light reaching the film or sensor.

When too much light reaches the film or sensor – at a given ISO rating – overexposure will occur. To correct this you can reduce the aperture or increase the shutter speed, both of these steps will decrease the level of light reaching the film or sensor.

THE LAW OF RECIPROCITY

When your meter or camera recommends an overall exposure level it expresses it as a combination of shutter speed and aperture at a given ISO setting. The nature of the relationship between aperture and shutter speed allows you to alter either of these variables without changing the overall exposure, provided that any change in one is compensated for by an equal and opposite change in the other. For example, if your camera recommends 1/500sec at f/4, you can alter the shutter speed to 1/250sec without altering the overall exposure provided that you change the aperture to f/5.6. This simple and very useful rule is known as 'the law of reciprocity', and it allows you creative control over the exposure variables without over- or underexposing the image.

RECIPROCITY LAW FAILURE

Unfortunately the law of reciprocity is not infallible, because of the way the sensitivity of film alters over long exposures. Film sensitivity decreases the longer it is exposed to light, this becomes apparent in exposures longer than one second. This means that the law of reciprocity no longer holds true, although the precise effect

Digital ISO Rating

In digital photography you can compensate for a change in aperture or shutter speed by altering the sensitivity of the sensor. For example, you could compensate for a one-stop increase in shutter speed by increasing the ISO rating by one stop, say from 200 to 400.

▼ *Photographic film suffers from reciprocity law failure. The sensitivity of film reduces the longer it is exposed, although digital sensors are not affected.*

depends on the film. This is referred to as reciprocity law failure and you should check your film's instruction sheet in order to find the correct amount of compensation that should be made. It is also a good idea to bracket your shots in order to ensure that you get the exposure correct.

Coping with Bright Sunlight

Surprisingly, bright sunshine can be one of the most difficult situations to expose for. The bright highlights and dark shadows can often confuse even the best meter but luckily there are a couple of useful rules of thumb to make things easier.

THE SUNNY f/16 RULE

In extremely bright conditions on a clear day you can use the simple but surprisingly accurate 'sunny f/16' rule. Simply set the aperture to f/16 and the shutter speed to the setting closest to that of the ISO rating in use. For example, with ISO 100, the sunny f/16 rule dictates that the eposure should be 1/100sec (or 1/125sec if this is the closest your camera offers) at f/16 . Once you have set the values you can then use the law of reciprocity to change the exposure settings, for example you could also use 1/50sec (or 1/60sec) at f/22.

104

▼ *When photographing in bright sunlight on a clear day you can use the sunny f/16 rule to set exposure. Although this is a simple technique, it is surprisingly accurate.*

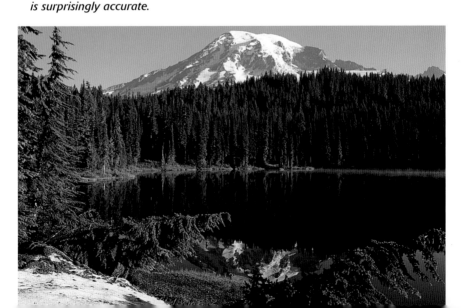

CREATE SILHOUETTES

When photographing a silhouette what you are trying to achieve is the removal of any detail in the surface that is in shadow.

To do this, just take a meter reading from an area behind the subject, excluding the light source itself. If this area is bright enough then the recommended exposure will render the shadow surface of the subject without any detail and you will be able to see only the dark silhouette.

▲ *Silhouettes are very effective in landscape photography and can produce some simple yet stunning results.*

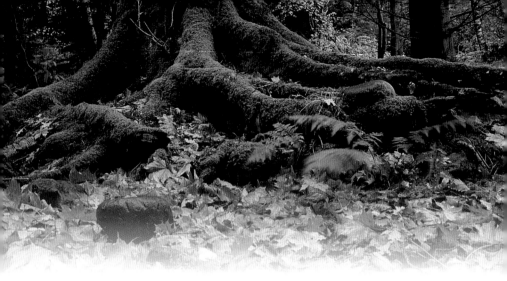

SEVEN **DESIGN**

All pictures are a composition of line, shape, colour, texture and pattern and, like an artist, you must choose where and how to use them within the picture frame, which is defined by your viewfinder.

Frame Format

The viewfinder of your camera is like an artist's canvas and the first thing you must consider is whether to use it in the horizontal or vertical format. Both formats are equally valuable but place a different emphasis on the subjects in your pictures. For example, holding the camera in the vertical position will accentuate height, which is useful when photographing trees or tall structures. On the other hand, with the camera held in the horizontal format, the emphasis is given to space, which can make the most of sweeping vistas. Changing the orientation of the picture frame alters the impact that an image has on us and, while there is no right way or wrong way to frame a given scene, your choice of horizontal or vertical format should be a conscious decision that accentuates the subject of the picture.

▶ *Compare the two pictures opposite and note how the choice of format affects how you perceive the scene. A vertical format, above right, accentuates the height of the tower, while a horizontal format, right, places the emphasis on the whole of the city.*

Aids to Composition

Some cameras, both film and digital, offer a grid-line display within the viewfinder. This is very useful for ensuring straight horizons and aiding composition. The more expensive SLRs on the market, and most medium-format cameras, offer interchangeable viewfinders, which can be used to provide several useful – albeit quite expensive – composition tools.

Elements of Design

Recognizing the lines, shapes and other design elements within the scene and then deciding how you choose to organise them within the frame are the basic components of making great landscape pictures. It is possible, of course, just to turn up and hope that you are in the right place at the right time and, if you follow this strategy, every now and then you will get lucky. But trusting to luck in this way is no way of improving your photography in the long term. Learning to identify the structure of subjects and then applying your knowledge of photographic technique to isolate and emphasize the individual elements of that structure in your pictures will make your images stand out from the crowd and lead to more successful results more often.

LINE

Line is the basic component in artistic design and the horizon-line is our natural point of orientation. Positioning the horizon in the middle of the picture space gives equal weighting to both halves of the image and can create a tranquil scene. Adjusting the horizon line up or down, however, causes the emphasis of the picture to become more dynamic. Horizontal or vertical lines are also static, in that they emphasise space or height but not motion. Diagonal lines, on the other hand, suggest movement, which gives us a greater sense of action. When two diagonal lines converge they lead the eye into the picture space, creating not only visual energy but also a sense of depth or height.

▶ *In this picture, the viewer is led through the frame by the converging lines, which accentuate depth. In this case, because the lines are vertical, they emphasize the height of the tree.*

STRUCTURE AN IMAGE

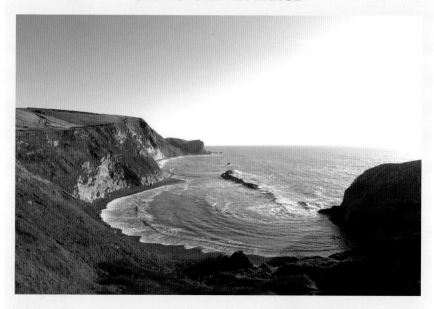

Look closely at the picture above and you'll notice that what holds your attention is the structure, as shown by the overlaying diagram, right. Your eye first follows the line of the cliff top from left to right, down to the point where land meets sea. Then, because the horizon line leads to nowhere (accentuated by the overexposure on the far right) you are drawn to the figure of eight shape of the beach and follow the curved line around to the opposite side. The rock jutting out into the bay then points you back via the diagonal line of the rocky outcrop to where you started and the process begins all over again.

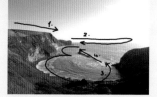

Shape

TRIANGLES

Shapes are everywhere in photographs and have a huge influence over how we 'see' a picture. Triangles, for example, evoke a sense of strength and permanence, as suggested by mountains. The simplicity of a triangle's shape and the solidity of its basic structure are what create in us the feeling of strength. However, if you invert a triangle it destabilizes the image by placing the bulk of the shape above a relatively small balancing point. Contrasting these orientations can increase the graphic statement your images make, evoking in us a sensation of suspense or danger even.

▼ *Triangles are dynamic shapes that cause tensions within the picture space and help to create a sense of visual energy. Depending on their orientation they can also give a scene a sense of permanence.*

▲ *The two circles of the fern fronds in this picture create a dynamic composition.*

▼ *Combining two different elements within the frame, has created a dynamic composition.*

CIRCLES AND SPIRALS

While triangles and polygons create tension, circles and spirals encapsulate motion giving us a far more comforting feeling. Consider again the image on page 110 and visualize how the shape of the bay keeps your attention locked within the figure of eight. And, here, the circular forms of the two fern fronds create energy within the picture space as your eyes follow their never ending line. Spirals in particular generate this perception of constant flow, seemingly only to begin again once you reach their end.

COMBINING SHAPES

Contrasting different shapes within an image is also a great way of creating visual energy in a picture, as your eyes focus on each shape in turn and flit between them. Often it is this energy that sets a compelling image apart from the also-rans.

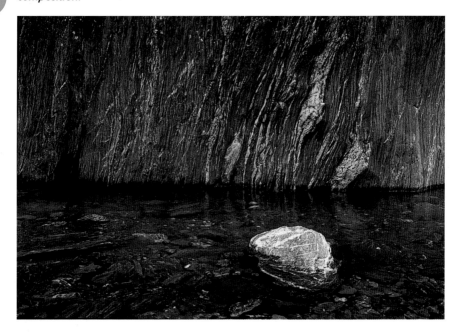

When thinking about picture design it is useful to consider your viewfinder as the equivalent to the artist's canvas.

1 Divide the space into nine equal parts – some cameras have an electronic grid that you can activate via the menu, which is useful for this task – and think about how the components within each of the nine 'boxes' work together.

2 If they seem disjointed then reframe the image until you create a more natural flow between the picture elements.

3 Remember that, in general, we read from left to right, top to bottom and replicating this natural order in your pictures will evoke an empathy with the viewer.

4 If, having reframed the image, you are still struggling to find the right composition, consider changing your position or adjusting the focal length of the lens to change your composition.

▼ *This image shows how distinct shapes within different parts of an image can be combined to form a cohesive whole.*

SEVEN

113

DESIGN

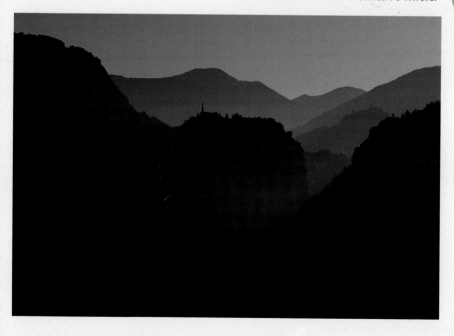

Colour

Colour is one of the most powerful communication tools outside language itself and we frequently use it in everyday life for that very purpose. For example, when you see a set of traffic lights you know that red means stop and that green means go. You don't need words to tell you, the colours themselves communicate the message. Colour also dictates whether we feel warm or cold. Red, orange and yellow – the warm colours of the spectrum – will give us a feeling of warmth while an image full of stark blues can make us shiver.

▶ *Colour affects the way we feel. Cool colours such as blue make us feel cold, while warm colours (red, yellow and orange) make us feel warm.*

COMBINING COLOURS

The real power of colour comes when you combine them in the image space. For example, colours that are complementary; red and green, blue and orange and yellow and violet have a remarkable effect on us as they generate tension. In particular, the combination of red and green give real visual energy and a sense of dimension and depth.

▼ *Colours react differently when used together. Harmonious colours are pleasing to the eye, which is one reason why we appreciate the colours of autumn when seen together.*

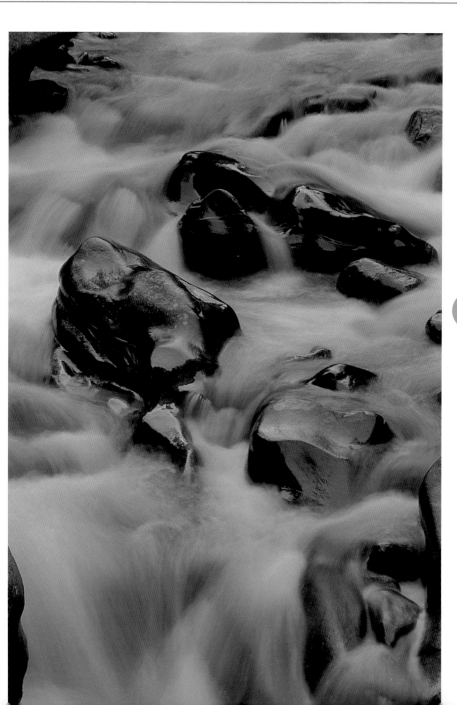

Positioning the Subject

W here you position the main subject within the frame will also affect what the photograph communicates to the viewer. You are faced with two choices: centred or off-centre. One of the best-known compositional techniques is the rule of thirds. The idea behind this rule is to divide the picture frame by drawing imaginary lines at one-third intervals horizontally and vertically across it, as shown below. Accordingly, the main part of the subject of the image should fall where the lines intersect. The asymmetric design produces tensions between the pictorial elements, which give your pictures more dynamism and visual energy.

Symmetry and asymmetry will dictate the visual weight of your pictures. A balanced, (symmetrical), picture tends to create a sense of tranquillity and stability, while an unbalanced, (asymmetrical) image will appear more dynamic.

▼ *Note how the position of the main subject influences your perception of the scene. Using the rule of thirds – placing the foreground boulder near one intersection and the castle near another – has helped to emphasize a sense of place.*

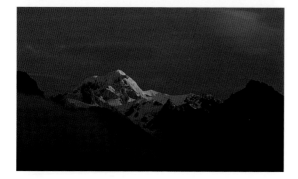

Breaking the Rules

Sometimes placing your subject centrally has an equally powerful effect. Positioning your subject in the middle of the picture space will hold your gaze on the centre, which is entirely appropriate if what is there is the most interesting part of the picture.

▲ *These two images show how symmetry affects the dynamics of a photograph. A balanced (symmetrical) design, top, creates a sense of stability, while an asymmetric composition, bottom, is more energetic.*

Pattern and Texture

Pattern and texture can make extremely effective photographic subjects and, with the requisite perspective and camera technique, you can create very powerful graphical statements by isolating these elements within the picture. Patterns – the repetitive organization of shapes – can be found everywhere you look, and altering your typical perspective can reveal these sometimes hidden subjects.

▼ *The overlaying lines within this landscape are an example of using pattern as the main subject of the photograph. I have used a telephoto lens to help accentuate the effect of the composition.*

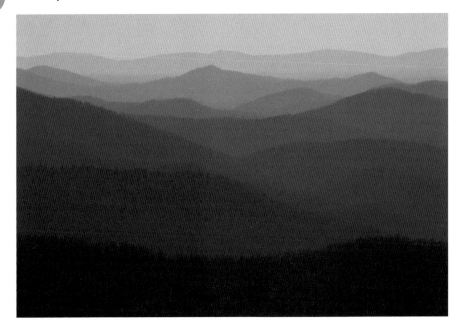

✔ You can create a sense of depth by including lines that converge. Good examples are railway tracks or the trunk of a tree viewed from the ground up.

✔ ▶ Placing complementary colours adjacent to each other, particularly red and green, will add a three-dimensional value to your pictures.

✔ The elements of design, as well as being intrinsic to the make-up of a photograph, can become the subjects themselves. Try isolating individual elements to create new and interesting compositions.

✔ Colour is an excellent tool for defining the mood of a picture. Strong, bold colours are punchy and create tension; red and orange will make a scene appear warm, while blue suggests cold; pastel colours are more soothing. Use colour to dictate emotional responses to your pictures.

✔ Constantly switch between different focal lengths to gain a different perspective of common subjects. A plain subject can be revitalized when looked at in a different way.

✔ Don't be too eager to rush from one area to the next. It's not unusual for me to spend an entire day photographing different aspects of the same place. It's amazing what you find when you look closely enough.

✔ To learn more about photographic design, study different forms of art. Books on art, architecture, graphic design and many other topics can reveal some interesting new angles to approach your subjects from.

3

DIGITAL IMAGE PROCESSING

- Digital Enhancement
-

EIGHT DIGITAL ENHANCEMENT

Selective exposure, dodging and burning, even unsharp masking have been part of darkroom technique for decades. Today these techniques are simple to apply and more accessible to all – via the computer.

START TAKING GREAT

122

LANDSCAPE PHOTOGRAPHS

There has been a lot of talk about the rights and wrongs of digital enhancement, much of it erroneous. From its earliest days, photography has always been a two-part process: image capture and image processing.

WHAT YOU CAN AND CAN'T DO

However powerful today's image processing software may be, it is always best to try to get the image as close to perfect in-camera as you can. For all it's potential, digital processing cannot create information that does not exist. If the picture is out of focus then it is out of focus and no amount of unsharp masking will help. If your highlights are washed out then altering the brightness level won't get your picture back on track. Digital processing should be seen as a resource to enhance image attributes that already exist but were limited by the parameters of film or camera – in much the same way as you should use photographic filters. Used properly and with constraint, digital processing will help you to create images of natural beauty that appear in print as you remember them in reality. The steps shown in this chapter are carried out using Adobe PhotoShop 7.0 on an Apple Mac, however, similar editing can be performed using other versions of Adobe PhotoShop, Adobe PhotoShop Elements, or for that matter any of the numerous programs that are available today for use on both Windows-based and Apple Mac computers.

▼ *The modern 'darkroom' can be found in a computer. This is a far cry from having to barricade yourself in the bathroom or being banished to the garden shed!*

✔ Making wholesale changes to digital images is often unrealistic, and can degrade the quality of the image. Choose a few simple corrections to make and don't be tempted to go too far.

✔ When you make changes to an image, save it with a different name to the original. This ensures that at no stage do you overwrite your first image, which should be kept as a back-up. Repeat this for every stage of the process so if you make a mistake you can simply return to the previous stage.

✔ Think carefully about the order in which you carry out digital enhancements. This helps to minimize time spent at the computer and prevent you from doing any unnecessary work. For example, cropping an image before removing dust means that you don't waste time on tidying up those parts of the image that will not be seen in the final photograph.

✔ Calibrate your system. This need not be complicated, simply follow the instructions that came with your monitor, printer, scanner and camera to ensure that what you see on screen, or on the back of your digital camera is as close as possible to what is printed.

✔ Less is more. The effects of some tools such as colour saturation can be very seductive on screen, but often look unrealistic when printed, if used excessively.

✔ Finally, but most importantly, back-up your work! All those hours spent photographing in the field, or in front of your computer are wasted if with one crash you lose your work. Ideally you should make regular back-ups and store them in a separate place so that if a disaster should occur, you will only lose a minimal amount of work.

✅ Adjusting Brightness and Contrast

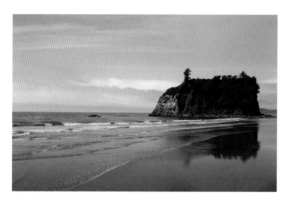

A well-exposed image should have a range of tones from black through to white. In practice, this doesn't always happen in the camera. However you can increase the subject brightness range in PhotoShop by following these simple steps.

▲ *Before adjusting brightness and contrast*

▼ *After adjusting brightness and contrast*

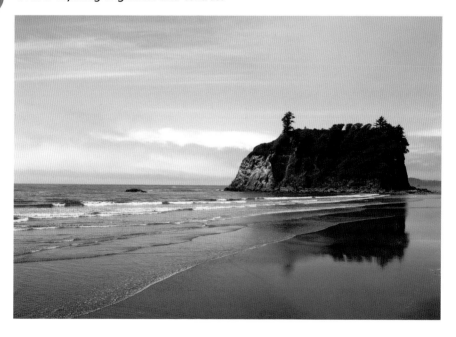

1 IMAGE > ADJUSTMENTS > LEVELS

2 Using the cursor, drag the left (black) slider until it aligns where the histogram begins on the left.

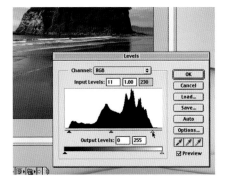

The computer will now remap the pixels so that the darkest pixels in the original image appear as black and the lightest pixels appear as white. You will notice an increase in contrast within the image.

3 Using the cursor, drag the right (white) slider until it aligns where the histogram begins on the right. Click on OK.

✔ Increasing Colour Saturation

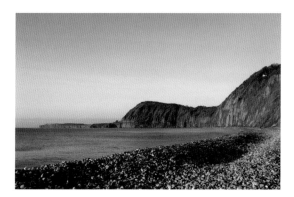

Bright, vivid colours always make landscape pictures stand out. If your images are looking a little flat, try adding a touch of saturation to give them a little bit more punch.

▲ *Before increasing colour saturation*

▼ *After increasing colour saturation*

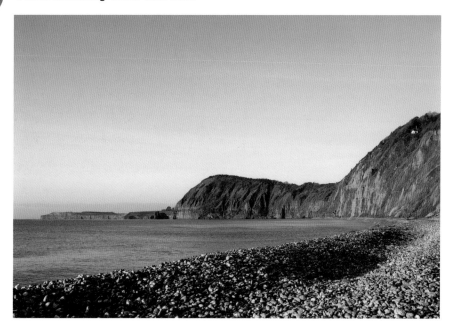

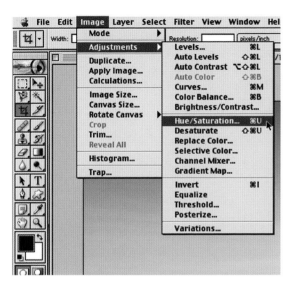

1 IMAGE >
ADJUSTMENTS >
HUE/SATURATION. Make
sure the PREVIEW box is
ticked so you can see the
changes as you make
adjustments.

2 Using the cursor, adjust
the saturation slider until
you get the affect you want.
An addition of somewhere
between +10 and +30 will
give good results that don't
look 'overcooked'. When
you're happy with the result,
click on OK.

✅ Removing Dust and Other Clutter

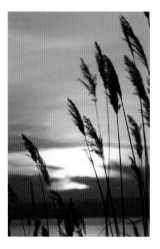

Dust is the bane of the digital photographer's life, but help is at hand. Using the **CLONE** tool you can remove dust specks and, for that matter, any other encroaching clutter from the scene.

▲ *Before removing dust*

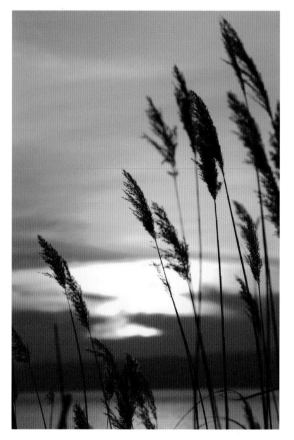

▶ *After removing dust*

1 Using the MAGNIFIER, enlarge the image so that the element to be removed fills the screen. Click on the CLONE tool. Select a CLONE BRUSH type and the correct size from the drop down menu.

2 Position the cursor adjacent to the dust spot or clutter and press the ALT key. This defines the area the computer will use to clone from. Position the cursor over the dust spot or clutter and LEFT CLICK with the mouse.

Repeat the process until the element to be removed has completely gone.

✅ Cropping

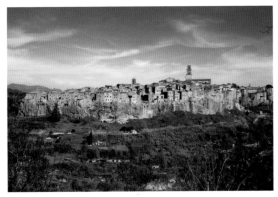

▲ *Before cropping*

It's not always possible to frame the image exactly as you want when you're on location. The CROP tool allows you to fine-tune your framing to improve your compositions. You can also use this tool to create picture formats other than the original by turning, for example, a 35mm frame into a panoramic scene.

▼ *After cropping*

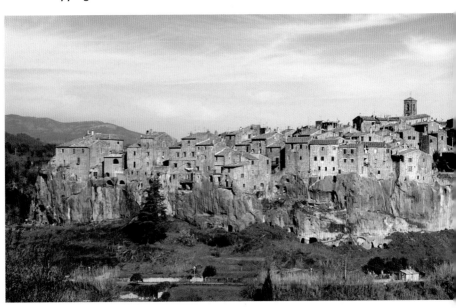

1 Select the CROP tool. Hold down the LEFT mouse button and draw the cursor around the area you want to crop. Once you've finished release the LEFT mouse button. The area outside the proposed CROP frame will darken. Adjust the CROP area until you're happy with the new frame. Click on the TICK box on the right of the menu bar.

✔ Using Unsharp Mask

You can bring out the detail in texture in a landscape by applying **UNSHARP MASK**. Don't overdo it, though, because you can just as easily ruin a picture with too heavy a hand.

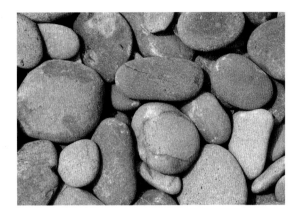

▲ *Before unsharp mask*

▼ *After unsharp mask*

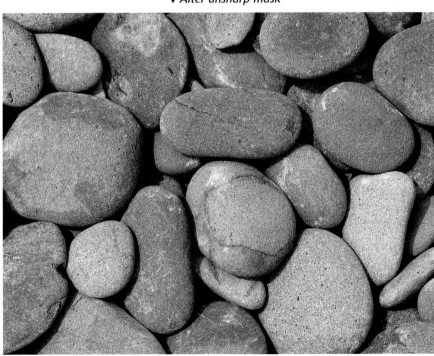

1 Make sure your image is saved as an 8-bit file. Select FILTER > SHARPEN > UNSHARP MASK. Make sure that the PREVIEW box is ticked.

EIGHT

DIGITAL ENHANCEMENT

2 Enter an amount in each of the AMOUNT, RADIUS and THRESHOLD boxes. Try a RADIUS of between 1 and 2 pixels, a THRESHOLD of between 0 and 1 level and an AMOUNT of between 100-200%. Once you're happy with the result, click on OK.

Note
Always apply all other image enhancement processes before you apply UNSHARP MASK.

✔ Straightening Horizons

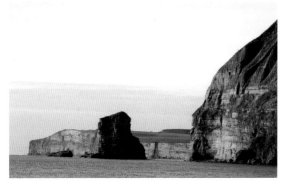

If your horizons are a little on the crooked side then you can use the **MEASURE** and **ROTATION** tools to get things straight.

▲ *Before straightening*

▼ *After straightening*

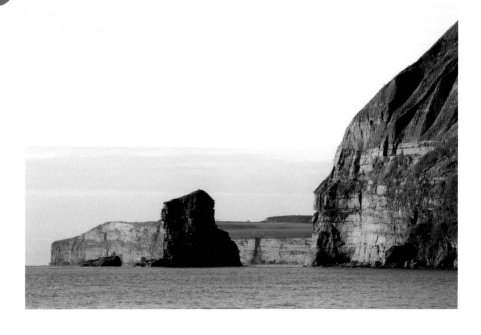

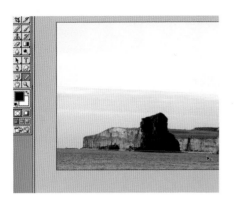

1 Select the MEASURE TOOL from the menu bar. LEFT click the mouse and draw a line along the horizon.

2 Select IMAGE > ROTATE CANVAS > ARBITRARY. The correct angle and direction of rotation is indicated by the computer (it uses the line drawn with the MEASURE TOOL to determine the correct values). Click on OK.

3 The image will now appear in the correct rotation, albeit with parts of the plain background visible.

4 Use the CROP tool to crop out the plain background caused by the rotation (see pages 130–1).

Useful Information

USEFUL COMPANIES:

Adobe
www.adobe.co.uk – UK
www.adobe.com – USA

Canon
www.canon.co.uk – UK
www.usa.canon.com – USA

Fujifilm
www.fujifilm.co.uk – UK
www.fujifilm.com – USA

Kodak
www.kodak.co.uk – UK
www.kodak.com – USA

Konica Minolta
www.konicaminolta.co.uk – UK
www.minoltausa.com – USA

Lee Filters
www.leefilters.com – UK
www.leefiltersusa.com – USA

Mamiya
www.mamiya.co.uk – UK
www.mamiya.com – USA

Nikon
www.nikon.co.uk – UK
www.nikonusa.com – USA

Olympus
www.olympus.co.uk – UK
www.olympusamerica.com – USA

Pentax
www.pentax.co.uk – UK
www.pentaxusa.com – USA

Sigma
www.sigma-imaging-uk.com – UK
www.sigmaphoto.com – USA

GENERAL PHOTOGRAPHY:

Depth of Field Calculator
www.shuttercity.com/DOF.cfm
http://tangentsoft.net/fcalc/

Digital Reviews
www.dpreview.com

Natural Photographic
Photography by Chris Weston
www.naturalphotographic.com

Photographers' Institute Press
Photography books and magazines
www.gmcbooks.com

Sunrise and Sunset Information
www.sunrisesunset.com

World Tide Information
www.ukho.gov.uk

Weather Information
www.bom.gov.au – Australia
www.weatheroffice.ec.gc.ca – Canada
www.metservice.co.nz – New Zealand
www.met-office.gov.uk – UK
www.nws.noaa.gov – USA

Glossary

Adaptor rings Circular mounting rings for adapting filter systems to a variety of lenses with different filter diameters.

Adobe PhotoShop A widely used image-manipulation program.

Ambient light Light available from existing sources as opposed to light supplied by the photographer.

Angle of view The angle extending from a lens that is captured.

Aperture The hole or opening through which light passes to expose the film. The size of the aperture relative to the focal length is denoted by f-stops.

Aperture priority An exposure mode in which the photographer chooses the aperture and the camera calculates the shutter speed for a correct exposure. If the aperture is changed, or the light level changes, the shutter speed is changed automatically.

Aperture ring A ring, located on some lens's barrels, which is linked mechanically to the diaphragm and controls the size of the aperture.

Aspect ratio The ratio of the width to the height of a frame.

Autoexposure The ability of a camera to recommend the correct exposure for a particular scene.

Autoexposure lock (AE-L) A function that locks an exposure setting while the image is recomposed.

Autofocus The camera's system of automatically focusing the image.

Ball and socket A basic tripod head.

Bracketing The process of exposing a series of frames of the same subject or scene at different exposure settings.

B(ulb)-setting A shutter-speed setting in which the shutter stays open while the shutter release button remains depressed.

Centre-weighted metering A type of metering system that weights the majority of its reading in the centre.

Cold colours Colours at the blue end of the visible spectrum, paradoxically they have high colour temperatures.

Colour temperature A description of the colour of light in comparison to the colour of light emitted by a theoretical perfect radiator at a particular temperature expressed in Kelvins (K).

Contrast The range between highlight and shadow areas of an image.

Cool-down filters Filters that are blue in appearance and have the effect of correcting warm colour casts or introducing cool colour casts.

Cropped sensor A digital sensor that is smaller than a 35mm frame.

Depth of field The amount of the image that is acceptably sharp. This is controlled by the aperture, the subject distance and the focal length. The smaller the aperture, the greater the subject distance and the shorter the focal length the greater the depth of field. Depth of field extends one third in front of and two thirds behind the point of focus.

Depth of field preview Some SLR cameras allow you to see the depth of field by stopping down the aperture while the mirror remains in place.

Diffuse lighting Lighting that is low or moderate in contrast, such as that which occurs on an overcast day.

Direct-vision A viewfinder (or camera that uses such a viewfinder) through which the subject is viewed directly, without light being diverted via a mirror.

EV (exposure value) A measurement of light given by an exposure meter that enables exposure settings to be calculated.

Exposure The amount of light that is allowed to act on a photographic material. Alternatively the act of taking a photograph, as in 'making an exposure'.

Exposure compensation A level of adjustment given (generally) to autoexposure settings. Generally used to compensate for known inadequacies in the way a camera takes meter readings.

Exposure latitude The extent to which exposure can be either increased or decreased without causing an unacceptable under- or overexposure of the image.

Exposure meter A device either built into the camera or separate with a light-sensitive cell used for measuring light levels, used as an aid for selecting the exposure setting.

Field of view The amount of a scene at a certain distance that a lens will include within an image.

Film A light-sensitive product consisting of photographic emulsion coated on a flexible, transparent base that records light over a period of time.

Flare Non-image-forming light that scatters within the lens system. This can create multi-coloured circles or a loss in contrast. It can be reduced by multiple lens coatings, low-dispersion lens elements or the use of a lens hood.

f-numbers A series of numbers on the lens aperture ring and/or the camera's LCD panel that indicate the relative size of the lens aperture.

Focal length The distance, usually given in millimetres, from the – often theoretical – optical centre point of a lens to its focal point.

Focal point The point at which all rays of light from a given point on the subject re-form after being refracted by a lens.

Focusing The adjustment made to the distance between the lens and the film (and therefore the focal point) in order to focus the image on the film.

Focus lock A mechanism on autofocus cameras that allows the point of focus to be locked while the image is recomposed.

Format The shape and size of a picture. Often used in reference to the size of the frame within the camera.

f-stop A fraction that indicates the actual diameter of the aperture: the 'f' represents the lens focal length.

Grain The visible silver deposit that forms the photographic image on film.

Grey card A grey card reflects 18% of the light falling on it, representative of a mid-tone subject used for calculating exposure.

Hyperfocal distance the distance between the lens and its hyperfocal point.

Hyperfocal focusing Focusing a lens on its hyperfocal point in order to maximize the available depth of field. The depth of field will extend from infinity to halfway between the camera and the hyperfocal point.

Hyperfocal point When a lens is focused on infinity the hyperfocal point is the point closest to the camera at which the image still appears acceptably sharp.

Incident light Light falling on a surface.

Infinity The distance at which objects are so far away that light reflected from them reaches the lens as parallel rays.

ISO The International Standards Organization standard measure for film and sensor sensitivity, in other words how quickly they react to light.

Landscape format A picture format where the frame is wider than it is tall.

Large format A term referring to a negative or transparency with a size of 5 x 4in or larger.

Lens coating A coating that is applied to a lens in order to diminish unwanted reflections and aberrations such as flare.

Lens hood A device attached to the front of the lens to prevent non-image-forming light from entering the lens barrel and causing flare.

Medium format Referring to photography using rollfilm (normally 120 or 220 rollfilm) that measures approx. 60cm wide. The frame size changes depending upon the camera.

Megapixel One million pixels = one megapixel. The power of a digital sensor is often given in megapixels: e.g. the Canon 10D has a 6.2 megapixel sensor.

Memory card Removable storage device for digital cameras.

Mid-tone A tone of any colour that reflects 18% of the light falling on it.

Mirror lock-up A function on some SLRs that allows the reflex mirror to be locked in the up position before exposure, thereby minimizing shake when the shutter is released.

Multi-segment metering A metering system that uses a number of variably sized and positioned segments to detect brightness levels and calculate an exposure value, sometimes in conjunction with the subject position.

Neutral-density (ND) filter A filter that reduces the brightness of an image without affecting the colour.

Neutral-density graduated (NDG) filter A grey filter that is graduated to allow different amounts of light to pass through the lens at different points, used to even up bright and dark tones, especially in landscape photography.

Noise The digital equivalent of graininess, caused by stray electrical signals.

Overexposure A condition in which too much light reaches the film or sensor, producing a dense negative or a light print or slide. Detail is lost in the highlights.

Pan and tilt A tripod head allowing movement in three axes.

Parallax The difference in viewpoint between the viewed image and the image recorded on film. This occurs in direct-view and TLR cameras.

Pixels Abbreviation of picture elements. The individual units which make up an image in digital form.

Polarized light Light waves vibrating in one plane only as opposed to the multi-directional vibrations of normal rays.

Polarizing filter A filter that transmits light travelling in one plane while absorbing light travelling in other planes. When placed in front of a camera lens, it can eliminate undesirable reflections except from metals. Also used to saturate colours (e.g. to make blue skies darker).

Portrait format A picture format where the frame is taller than it is wide.

Prime lens A fixed focal length lens.

Reciprocity law A change in one exposure setting can be compensated for by an equal and opposite change in the other. For example, the exposure settings of 1/125sec at f/8 produce exactly the same exposure value as 1/60sec at f/11.

Reciprocity law failure At shutter speeds slower than one second the law of reciprocity begins to fail because film sensitivity reduces as exposure increases.

Remote release A shutter button that is located off-camera. Remote releases can use infrared, electrical wire or solid cable.

Rule of thirds A compositional device that places the key elements of a picture at points along imagined lines that divide the frame into thirds.

Shutter priority An exposure mode on an automatic camera that lets you select the desired shutter speed; the camera sets the aperture for correct exposure. If you change the shutter speed, or the light level changes, the camera adjusts the aperture automatically.

Shutter release The button or lever on a camera that opens the shutter.

Shutter speed The length of time that the shutter is open. Measured in seconds or fractions of a second.

Silhouette A backlit image in which all surface detail is lost.

Skylight filter A filter that is used to cut out ultraviolet haze. It also warms the image slightly.

SLR (single lens reflex) A type of camera that allows you to see the image through the camera's lens as you look through the viewfinder.

Spot metering A metering system that measures light from a very small area, this can sometimes be linked to autofocus..

Standard lens A lens that provides approximately the same angle of view as the human eye.

Subject brightness range (SBR) The exposure range between the lightest portion of a scene and the darkest.

Telephoto A lens with a narrower angle of view than the human eye.

Through-the-lens (TTL) metering A meter built into the camera that determines exposure for the scene by reading light that passes through the lens.

T(ime) setting A shutter-speed setting in which the shutter opens with the first press of the shutter release and then closes with the second press.

Underexposure Too little light reaching the film or sensor, producing an image where detail is lost in the areas of shadow in the exposure.

UV filter A filter that reduces UV interference in the final image, particularly reducing haze in landscape photographs.

Vignetting The darkening of the corners of an image that can be caused by a generic lens hood or by the design of the lens itself.

Warm colours Colours at the red end of the visible spectrum, paradoxically they have low colour temperatures.

Warm-up filters Filters that add a warm colour cast to an image, or correct a cold colour cast.

White balance A function on a digital camera that allows the colour balance to be altered to render correct tones.

Wideangle Lenses with a wider angle of view than the human eye.

Zoom lens A lens with a variable focal length, normally altered via a collar.

Index

143